ARIZONA
ODDITIES

ARIZONA
ODDITIES

—— LAND OF ——
ANOMALIES & TAMALES

MARSHALL TRIMBLE

THE
History
PRESS

Published by The History Press
Charleston, SC
www.historypress.com

First published 2018

Manufactured in the United States

ISBN 9781467140492

Library of Congress Control Number: 2018945787

Notice: The information in this book is true and complete to the best of our knowledge. It is offered without guarantee on the part of the author or The History Press. The author and The History Press disclaim all liability in connection with the use of this book.

To my beautiful wife, Vanessa.
You not only light up my life but you also are a dang good proofreader.

CONTENTS

CONTENTS

ACKNOWLEDGEMENTS

I first met Kevin Schirmer when I was teaching Southwest history at Coronado High School in Scottsdale in the mid-1970s and later at Scottsdale Community College when he took my Arizona history class. He also worked in a camera store and in a reversal of teacher-student, he taught me how to be a good photographer. Fast-forward a few years, and he became my manager. Through it all, he's been a good friend. Kevin played a major role in the technical aspects of the photos in this book. I couldn't have done it without him.

Donna Cole, another of my former students, is today executive secretary at Scottsdale Community College. Donna is a genius when it comes helping me try to overcome being computer-challenged. Most of all, she's a very special friend.

Hao Thai works in the front office of the Administration Building at the college. She has a smile that is bigger than the state of Texas and a personality to match. She is always willing to stop what she's doing to fix my computer when the demons sabotage my writing.

Last but not least is my wife, Vanessa. She has eagle eyes when it comes to proofreading. Oftentimes, after I've called it a night, she's in there cleaning up something I've just written. I can't help it if my brain works faster than my fingers.

INTRODUCTION

Arizona is a place that lives by its myths and legends. The wild, untamed country that lies between New Mexico and California was a dry, desolate, sunbaked land of jagged mountains and barren deserts. Early immigrants on their way to California claimed the wind was hot as a dragon's breath, rattlesnakes were as big around as wagon tongues, cowboys heated their branding irons by pointing them at the sun and the rivers were so hot that when people jumped in to cool off they would emerge with third-degree burns.

But those same jagged mountains bore treasures of gold, silver and copper that were beyond a Spanish conquistador's wildest dreams. Arizona was a diamond in the rough. In time, railroads would be built, the truculent rivers would be harnessed and air conditioning would be invented.

What do people like most about Arizona today? In a word—or four—open spaces and lifestyle. Arizona is the sixth-largest state in the nation. All of New England plus Pennsylvania and Delaware would fit inside its boundaries. Open spaces? Some 90 percent of the people live on just 2 percent of the land. There are ninety-two wilderness areas and thirty-two mountain peaks over ten thousand feet in elevation. The state boasts thirty-two state parks along with twenty-two national parks and monuments. In the wintertime, it's possible to go snow skiing in the San Francisco Peaks in the morning and water ski on Saguaro Lake that afternoon.

Only one of the Seven Wonders of the World is a canyon, and that's why Arizona's official nickname is the Grand Canyon State. America's

two largest man-made lakes, Mead and Powell, border the state. Arizona is the only state that contains a part of all four of North America's deserts: the Sonoran, Chihuahua, Mohave and Great Basin. The Sonoran Desert has the most diverse plant and animal life of all the deserts in the world. And thanks to such lofty mountain towns as Flagstaff, Williams, Alpine, Greer, Pinetop and Show Low, Arizona is only the eleventh-hottest state in the nation.

Arizonans like to call this place a land of anomalies and tamales because of the contrasts and contradictions that make the Grand Canyon State unique. For example, the first cattlemen were the Jesuit priests, who introduced cattle ranching in Arizona in the late 1600s, and the first "cowboys" were the mission Indians. The first great cattleman was a woman. Eulalia Elias ran the Babocomari Mexican land grant from 1827 to 1849. The namesake for America's most famous lost mine, the Lost Dutchman, wasn't a Dutchman, and he wasn't lost. Jacob Waltz actually was a German. The Gunfight at O.K. Corral didn't occur at the O.K. Corral. The storied fight between the Earp brothers and Doc Holliday against the McLaury brothers and Billy Clanton took place on Fremont Street between Fly's Photograph Gallery and the Harwood House.

But wait, there's more: the first white man to come to Arizona was a black man. Esteban was an African, scouting for the Coronado Expedition. He arrived in 1539. The Spanish colonial army commanding officer who founded the presidio in August 1775 that would become the city of Tucson was a red-headed Irishman named Hugo O'Conor. The Indians called him "Captain Red." The first native Arizona cowboy movie star was a cowgirl. Dorothy Fay Southworth of Prescott headed out to Hollywood in the 1930s and was soon starring in western movies. In 1941, she married her favorite leading man, one of Hollywood's most popular singing cowboys, Tex Ritter. She also was the mother of the late actor John Ritter. The world-famous Navajo Taco was invented in Window Rock by a Greek immigrant, and New York's popular mayor from 1934 to 1945, Fiorello La Guardia, was raised in Prescott.

Speaking of Prescott, the first territorial capital of Arizona was named for historian William Hickling Prescott. The correct pronunciation is Pres-cot, but to pronounce it as such in one of the saloons on Whiskey Row might cause the bartender to double the price of your drinks. Most prefer Press-kit or Press-cutt.

Many of Arizona's place names are a mix of Native American, Spanish and local American colloquialisms. The following are a few examples:

The Mogollon Rim, known as "Arizona's Backbone," is named for a sixteenth-century Spanish governor, Juan Ignacio Mogollon. It's pronounced either "Muggy-on" or "Muggy own."

The old frontier military post in Cochise County, Fort Huachuca, is pronounced "Wa-CHOO-kuh."

Those lofty pinnacles we call the Four Peaks, northeast of the Salt River Valley, are in the "Mah-zaht-zahl" mountain range. Locals have simplified it to "Mat-a-zel."

That venerable Spanish mission south of Tucson San Xavier is not pronounced "San Ex-Zavier" or "San X-Avier," it is "San Ha-vier."

Casa Grande, the town and national monument in Pinal County, is usually pronounced "Cass-ah-Grand," but the correct pronunciation is "Cossa-Gron-day."

Arizona's most historic river, the Gila, flows some 630 miles in a westerly direction across the state and connects with the Colorado River at Yuma. Its correct pronunciation is "Hee-la."

Grand Falls is on the Little Colorado River in Navajoland. The falls has a drop of 185 feet, higher than Niagara Falls by 18 feet. Typical of many rivers in Arizona, the Little Colorado is dry most of the time, but when it flows, the water is quite muddy. It's affectionately known as "Chocolate Niagara."

Arizona has a number of communities with unusual place names. In the White Mountains north of the Mogollon Rim is the largest stand of ponderosa pines in the world. Back during the Apache Wars, soldiers traveling between Fort Verde and Fort Apache stopped off at Walter Rigney's saloon for a cool one. Rigney was a tall man with bushy hair that stuck out like a pine bough, and the soldiers called him "Old Pinetop."

After the war ended, settlers began moving in and built their cabins near Rigney's saloon, and in 1895, the citizens decided to name their town Pinetop. So, in the largest stand of ponderosa pine trees in the world is a town named Pinetop—not for the pine trees but for a tall, bushy-headed bartender.

Up in the high country is a town named Snowflake, and while it does snow there in the winter, the community wasn't named for the winter weather but for two Mormons: Erastus Snow, a Mormon apostle, and William J. Flake, a cattleman.

The residents of Moccasin have to drive 360 miles and go through three states just to get to their county seat. The distance from there to Kingman as the crow flies is only 140 miles, but the crow flies over the Grand Canyon.

The locals have to go around it by driving north into Utah, then west into Nevada, crossing back into Arizona at the Hoover Dam and then driving another hundred miles to Kingman.

Do you think Central, Arizona, is in the center of Arizona? Guess again—it's a community of about six hundred on the Gila River in the far eastern part of the state halfway between the communities of Thatcher and Pima, hence the name "Central."

During the 1880s, Henry Mortimer Coane became postmaster of a small farming community in the Verde Valley. As often happened in the case of a new town, the postmaster named it after himself. In a letter to postal authorities, Henry suggested the name Coanville. Somebody in the nation's capital misread the name and officially dubbed the town Cornville.

In the Sonoran Desert between Gila Bend and Lukeville on the Mexican border is a small community named Why. The population numbers somewhere around one hundred. Tourists passing through were inclined to ask, "Why would anyone want to live here?" In 1965, the locals responded by officially naming the place "Why."

Another desert community is named Hope. Nearby is where General George Patton trained his soldiers for desert warfare prior to the invasion of North Africa in World War II. Soldiers claimed if you had a bottle of beer that was less than 100 degrees it was considered a cold one. Despite the isolation, the locals are proud of their little community, as evidenced by a roadside sign on the outskirts of town that says, "If you can read this, you're beyond Hope."

Arizona's town and county names tend to confuse newcomers. The town of Gila Bend is located not in Gila County but in Maricopa County. The town of Maricopa is in Pinal County. Santa Cruz isn't in Santa Cruz County; it's in Pima County. The community of Pima is found in Graham County. Fort Apache is in Navajo County, while Navajo is in Apache County.

Arizona's youngest county, La Paz, is officially America's oldest. The reason for this contradiction? One-third of the population, according to the U.S. Census Bureau, is sixty-five years old or older.

Arizona also boasts some unusual place names. Back in the 1930s, when the Civilian Conservation Corps was mapping the area near Sedona, an engineer asked one of the locals the name of a particularly treacherous canyon so he could mark it on the map. The worker shrugged and replied, "Damned if I know."

The engineer thought he said "Damfino," so that's what he wrote down. And the canyon still bears that name. Mistake Peak is a physical description.

When viewed from the Tonto Basin, it looks to be part of a main range, but when seen from the opposite side, it looks like a separate peak—so mapmakers decided to dub it "Mistake." No Name Mesa on the Arizona-Utah border actually has a name—No Name.

Back in 1910, government surveyors thought they were looking at Rincon Peak and wrote it on their map. After learning they'd named the wrong peak, they renamed it Wrong Mountain.

Arizona's usually dry rivers are famous for their sometimes capricious behavior. In 1885, the citizens of Florence petitioned the territorial legislature for a bridge across the Gila River so they could get to the Salt River Valley when the river was up. They got their appropriation, and the bridge was built and dedicated. One morning, the citizens looked out to see the restless river had changed its course, bypassing the bridge and leaving it standing alone in the desert.

In 1846, when the Mormon Battalion crossed Arizona during the Mexican War, Lieutenant George Stoneman decided to test the navigability of the Gila. His men built a raft and loaded it with supplies, and the young lieutenant cast off into the Gila, floating only a short distance before the naval craft sank. Like any good skipper, Stoneman went down with his ship, then walked ashore. Far as we know, it's the only U.S. naval vessel to sink in the Gila.

Two years later, the Howard family was floating down the Gila when Mrs. Howard, who was expecting, decided the time had come. They pulled ashore; she gave birth to a baby boy and promptly named him Gila. Gila Howard became the first American baby born in what would become Arizona.

During the 1920s, the federal government decided to build a dam on the Gila. Unfortunately, the surveyors picked an unusually wet year and chose a site in a narrow canyon east of Hayden. The dam was built and named Coolidge for the former president, but by the time it was dedicated, Arizona was in another drought and nothing but tall weeds grew where the lake was supposed to be. Calvin Coolidge was there, but he didn't have much to say about the waterless reservoir. He wasn't known as "Silent Cal" for nothing. But humorist Will Rogers was never at a loss for words. He looked out across the sea of weeds and quipped, "If that was my lake, I'd mow it."

Senator Barry Goldwater told a story about his grandfather Mike, who had a mercantile store in the Colorado River port city of La Paz. He woke up one morning to find the river had changed its course, and La Paz was now perched on the banks of a dry arroyo. He packed his merchandise in a wagon and set out to find the river, and when he did, the store was rebuilt.

He named the new town Ehrenberg for his old friend Herman Ehrenberg, a German engineer whose luck finally ran out in the Mohave Desert in 1866 when an Indian war party sent him to the "long sleep."

Tucson is known as the only city in the world that has a shrine dedicated to a sinner. The shrine is called El Tiradito, "The Little Castaway," and located in Tucson's Barrio Viejo. There are many versions of how it came to be, but a favorite goes back to the 1870s and an ill-fated love affair between a young sheepherder named Juan Oliveras and his mother-in-law. The father-in-law discovered the pair during a romantic tryst and proceeded to kill young Juan in a jealous rage.

Since Juan was a sinner, he couldn't be buried in consecrated ground, so he was laid to rest on the spot where he died. In time, the tête-à-tête must have awakened a long-suppressed cougar in some of the mature women in the barrio because, as time went by, they began to romanticize the affair and visited the site to light candles and pray that Juan be forgiven. Soon it became a shrine for parents concerned about their flirtatious daughters. Visitors began to come to the shrine to light a candle and make a wish. The legend grew that when the candle burned through the night, the wish would be granted. Some claim to have heard Juan's remorseful mother-in-law crying in the night for her young lover.

Arizona prides itself in being a sanctuary for unusual or outrageous characters. One of those was Bill Esenwein, a writer and prospector around the town of Congress. He was better known as "Rattlesnake Bill." He earned the nickname as a result of his rapport with venomous reptiles. You might say he was the Dr. Doolittle of diamondbacks. He rescued the reptiles, took care of them and allowed them to live with him.

Out on U.S. Highway 89 in the town of Congress, situated between Wickenburg and Prescott, the Arrowhead Restaurant had a small zoo with a snake pit. Bill would drop by occasionally and complain the snakes weren't getting enough to eat. He conjured up a concoction of raw eggs and hamburger that he claimed would fatten up the snakes. He would climb down into the pit and force-feed them with a tube.

Bill's slithery roommates also acted as burglar alarms when he needed to go into Wickenburg. He placed his valuables on a table in the middle of the kitchen, and the snakes would be shepherded into the room and corralled with chicken wire. Bill claimed he was never burglarized, and nobody ever doubted it. He also claimed he was never bitten, but one day someone noticed his hand was badly swollen. He was taken into Wickenburg, and sure enough, one had nailed him on the finger. Bill always insisted the snake

didn't mean to do it. His old cabin still sits near the Octave Mine at Stanton. It's called Rattlesnake Haven.

Over in the wild and woolly town of Clifton, a hard-rock miner named Marguerito Varella was hired to build a jail by hollowing out a cave in the side of a mountain. He blasted and drilled and, upon completion, was paid in cash. He headed for the nearest saloon, bought a drink and proudly proposed a toast to the "World's Greatest Jailmaker." When the unappreciative customers refused to raise their glasses, he pulled his six-shooter and commenced to shoot holes in the ceiling. The bartender, who also was the town constable, hauled him off to become the first inmate in the new town jail.

Jim Sam was one of the earliest Asians to arrive in America during the California Gold Rush. In 1865, he opened a restaurant in Prescott and eventually operated restaurants in a number of mining towns around the territory.

Sam had a knack for making money in the restaurant business, and he grubstaked many a prospector. He was a soft touch for every down-on-his-luck sourdough who crossed his path. He kept a record of every dollar he loaned but never ran a total until one day the thought struck him to find out how much was owed. Much to his surprise, the total came to $164,000. So, he decided to go out and locate his own gold mine but, after several tries, never found that bonanza. His forte was running restaurants and charging the exorbitant price of $1 per meal. He was an excellent shot with a pistol and often put on exhibitions by shooting the marks out of playing cards from a distance.

While he was running a restaurant in Globe, some of the town rowdies visited his establishment, bent on shipping him back to China. Jim Sam stuck a large knife in his teeth, armed himself with two pistols and plowed into the bunch. He didn't shoot any of them but did beat a couple severely about the head and shoulders with the barrels of his pistols. Far as we know, nobody ever messed with Jim Sam again.

General William Tecumseh Sherman was among those who were not favorably impressed with Arizona. In reference to the vexing campaigns against the Apache, he allegedly said, "We had one war with Mexico to take Arizona, and maybe we should have another to make her take it back."

Sherman made a whistle-stop visit in the early 1880s. Sherman's host, Captain William Hancock—the man who surveyed the townsite that became the city of Phoenix—suggested that Arizona was a pretty nice place and all that it needed was less heat and more water.

The crusty old general scoffed and replied, "Less heat and more water. That's all hell needs."

Army wife Martha Summerhayes, upon arriving in Ehrenberg, Arizona, by steamboat in the summer of 1874 wrote: "Of all the miserable-looking settlements one could possibly imagine, that was the worst."

I can't vouch for the veracity of this story, but it's worth tellin': Yuma County folklore says an old harridan by the name of Latrina Passwater owned a ranch down along the Colorado River near Yuma. Her west pasture backed up to the river, which was known for changing its course without warning. She looked out one morning to find it had cut a new path around the east side of her place.

A local newspaper reporter rode out and asked Latrina what she thought of becoming a Californian.

With a straight face, she replied, "That's okay with me. I don't think I could stand to spend another summer in Arizona anyway."

TOMBSTONE BEYOND THE O.K. CORRAL

A few years ago, I was standing on a street corner in Tombstone when a gentleman and his family approached me and asked if I knew anything about the town. I replied, "A little. How can I help you?"

"We were told the next gunfight isn't for another forty-five minutes. Is there anything else we can do while we're waiting?"

I told him about the wonderful tour of the old Good Enough Mine located beneath the town and the fascinating presentation of the history of Tombstone's rich silver mines.

He gave me a puzzled look and asked, "Did they have *mining* in Tombstone?"

I thought about replying, "Not really, they just had gunfights in the street every forty-five minutes."

But I'm always patient and kind to tourists, so I gave him a short history of Ed Schieffelin and his storied discovery of silver in the hills south of town.

His response provided the inspiration for this story. You see, nine out of ten of the early inhabitants were quiet and respectable homebodies. It was the noisy 10 percent that kept the double doors swinging all night, the glasses clinking and the poker chips changing hands.

In 1880, Tombstone attorney Wells Spicer wrote:

> *The town is not altogether lost, even if there is a population of 1,500 people with two dance houses, a dozen gambling places, over twenty saloons*

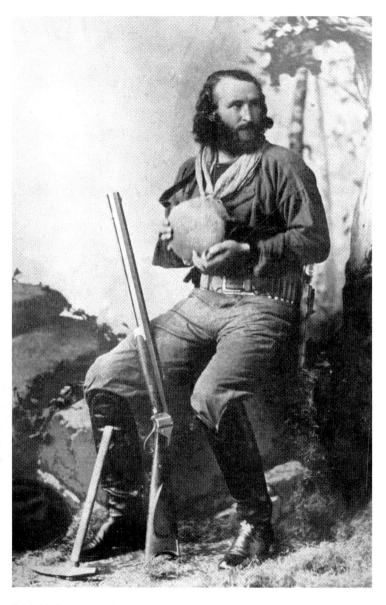

Ed Schieffelin was a down-on-his-luck prospector until he struck it rich in 1877. The soldiers had told him that all he would find in the dangerous Apache country would be his own tombstone. So he named the town that sprang up around his mine Tombstone. *Public domain.*

and more than five hundred gamblers. Still there is hope; for I know of two Bibles in town, and I have one of them (borrowed).

In June 1880, Philip M. Thurmond walked around the newly formed mining camp of Tombstone and asked for the vital statistics of every person he could find. Acting on a federally mandated census, Thurmond tabulated 2,170 residents from all over the globe: Germany, Ireland, England, Canada, Mexico, Sweden, Switzerland, France, Spain, Japan, China and South America were represented. Tombstone had become a cosmopolitan little city.

By mid-1881, there were several fancy restaurants, including Chinese, Italian and Mexican; upscale Continental establishments; and many home cooking hot spots, such as Nellie Cashman's famous Russ House, where an evening meal cost fifty cents—breakfast and lunch less.

Sherry Monahan, in her book *A Taste of Tombstone*, noted:

French food was trendy in the town. There was a French restaurant where extravagant French food was served. Even the menus were in French. Also on the menu was fresh fish and shellfish, oysters and lobster brought in from Baltimore and California. A gourmet might even order oyster under glass.

Tombstone could afford to serve the very best wines and liquors. Kelly's Wine Bar had twenty-six brands imported from Europe. Believe it or not, the gin fizz toddy was a favorite in Tombstone.

Imagine Wyatt Earp and Doc Holliday bellying up to the bar and saying "Barkeep, we'll have a gin fizz toddy."

Other establishments included a bowling alley, an icehouse, a school, an opera house, two banks, three newspapers and an ice cream parlor. In addition to those establishments were 110 saloons, 14 gambling halls and numerous brothels. All were located around and on top of rich deposits of silver lodes worth millions of dollars.

There were several butcher shops in town, as beef was a big part of the miners' diets. In an effort to thwart cattle rustlers and protect ranchers, the territory enacted a law on February 12, 1881, regulating the butcher business, holding butchers responsible for keeping records describing the animal, age, weight, brand and the name of the seller—and holding the hide for inspection for ten days from the slaughter date. A man convicted of cattle theft could spend one to ten years in the territorial pen.

The Arizona Telephone Company began installing poles and lines for the city's first telephone service on March 15, 1881. It didn't happen, but

it is plausible that when Wyatt Earp passed the Oriental Saloon on his way to the Gunfight near the O.K. Corral the bartender could have stepped through the swinging doors and said, "Mr. Earp, telephone call for you!"

During the 1880s, Tombstone had a population of about five hundred Chinese. The best-known resident was a lady named Sing Choy, but she was better known as China Mary. The Chinese often adopted white names such as Mary or John. An astute businesswoman, she became the absolute ruler or "godfather" to the Chinese community. She ran a store, controlled the opium dens and gambling and secured jobs for Chinese laborers in the community.

China Mary also controlled all the Chinese prostitution in town. She supplied hops to the soiled doves in the red-light district. In spite of some of her questionable business dealings, China Mary was respected and well-liked by the denizens of Tombstone.

China Mary was married to Ah Lum, co-owner of the famous Can Can Restaurant. She usually wore brocaded silks and large jade jewelry. She also was influential among whites and people of other nationalities. Her word was as good as that of a judge or banker. The white residents, who preferred Chinese domestic labor, soon learned that Mary was resourceful in finding the best workers. She guaranteed their honesty and workmanship. Her guarantee was "Them steal, me pay!"

All work was done to the employer's satisfaction, or it would be redone for free. Payments were made not to the employee but to China Mary, who always took her commission off the top.

China Mary managed a well-stocked general store, where she dealt in both American and Chinese goods. White men and Asians were both allowed to play in the gambling hall behind her store, but they had to abide by her rules. China Mary seems to have been an astute investor, too; she was involved in a number of businesses, including several hand laundries and a restaurant owned by Sam Sing. Mary was a moneylender, and she used her own judgment to determine borrowers' credibility.

China Mary is remembered as a generous lady who helped those in need of money or medical care. No sick, injured or hungry person was ever turned away from her door. She once took a cowboy with a broken leg to the Grand Central Hotel and paid all his medical bills.

When Mary died of heart failure in 1906, many of the townsfolk turned out for her funeral. She was buried in Tombstone's Boothill Cemetery.

Located in the Chihuahua Desert, at an elevation over 4,500 feet, Tombstone was cold enough in the winter that a fire was necessary.

George Parsons, Tombstone's chronicler, was born in Washington, D.C, and trained as a lawyer. That line of work didn't suit him, and he wound up in Tombstone in February 1880. Much of what we know about the town's characters, from Wyatt Earp to Dr. George Goodfellow, is due to his diary. *Wiki Commons (CC BY 2.0).*

However, firewood was scarce as horseflies in December. This was high desert, void of tall pines, and the ubiquitous mesquite trees were the only source of firewood to be found. The residents soon found the roots of the mesquite made for excellent firewood. The hard wood held the heat as good as coal. The locals would stick their picks into the ground, pry up the long black roots, cut them and load their wagons.

Newcomers to Tombstone or any other mining town in the West had to learn another trick—stealing cats. If one hoped to get a good night's sleep and protect his food supplies from pesky rodents, he needed a good cat, and the ornerier the better. Tombstone chronicler George Parsons wrote in his journal: "The rats run about us all night making great racket....Rolled over on one in the night and killed him—mashed him deader than a door nail."

Cats were scarce—hard to find and harder to keep. Steal one from your neighbor and two weeks later somebody pilfered it from you. Parsons told a story in his journal about one night he and a couple of friends were on their way home from church.

"We came across two out promenading and tried to capture one [cat]. I was successful and hurried mine home anxious to get there before I was clawed or bitten to death. Peace amongst the rats."

Dogs also were important but for another reason, especially for those living on the outskirts of Tombstone. Renegade Apaches sometimes raided, and the barking sounded the alarm. During the first years of the mining camp, dogs were scarce and often stolen, but later on, they were so plentiful that the city had to require they be licensed.

That basic necessity for life, water, also was scarce in Tombstone. Dave Chamberlin dug the first wells and sold fifty-gallon barrels of water for two dollars per barrel. A double team pulling a five-hundred-gallon tank wagon

could make two trips and garner twenty dollars a day—good wages when one considers a hard-rock miner was only making about four dollars a day.

It didn't take long for an enterprising operator to open a stage line from Tucson to Tombstone. The first was J.D. Kinnear, who in November 1879 began a once-a-week service from Tucson, a journey of some seventy-five miles.

The trip began on a Tuesday and arrived in Tombstone the following day. It would then leave for Tucson on Friday and arrive on Saturday. A one-way ticket cost ten dollars. Soon Kinnear was able to purchase a four-horse Concord stagecoach and cut his time to Tombstone to just seventeen hours.

Another stage line opened for business in 1880 and cut the fare to seven dollars, but it had a short history. A third line, the Ohnesorgen and Walker Stage Company, not only cut fares but also lowered the cost of shipping bullion. It offered thrice-weekly service and used a six-horse coach, cutting the road time to just thirteen hours and eliminating the overnight stop. Kinnear countered with four trips a week.

The competition was a benefit to both passengers and businesses. Soon there was daily service to Tombstone, and ticket prices eventually dropped to just three dollars. Both lines were losing money at those prices, so they compromised, and the one-way tickets were set at seven dollars. This lasted until the Southern Pacific Railroad reached Benson in June 1880 and reduced the route to just twenty-six miles.

When families began arriving, a clamor arose for schools. The first one opened in February 1880 with dirt floors. The desks were boards on packing boxes; seats were planks on nail kegs. The teacher's desk was an upside-down flour barrel.

School opened with nine students, and by the end of the term, the enrollment had increased to more than forty. Many of the older students were working cowboys on their fathers' ranches and came to school packing pistols. A new teacher, obviously unfamiliar with firearms, collected the pistols from the boys and threw them in the stove without removing the bullets. The fireworks that resulted sent both students and teacher running for cover.

A teacher over in Charleston, H.E. Weatherspoon, met his students at the door and checked in their pistols, much like the gun ordinances in Tombstone, which allowed men to carry their pistols only upon entering or leaving town.

The mostly young, single miners earned about twenty-four dollars a week working six-day ten-hour shifts, while teamsters received forty to sixty

dollars a month plus board. Clerks working in the mining offices made fifty to one hundred dollars a month. One could room at a boardinghouse for twenty dollars a month and eight to ten dollars a week for meals.

Fires were always a menace in the mining towns. Homes and businesses were mostly built with lumber, and the combination of woodstoves and coal oil lamps posed a constant danger of fires.

Tombstone endured three major fires. The first occurred on June 22, 1881, the second nearly a year later and the third a few months later. With typical frontier fortitude, the residents quickly rebuilt, each time using a little more brick and mortar.

In 1881, Tombstone had a population of some seven thousand, and in 1883—at the peak of the mining boom—the town's recorded population was about ten thousand; however, hundreds more were living in the surrounding hills. Small enclaves of miners huddled together in the "suburbs" for protection, giving their abodes colorful names like Hog-Em, Goug-Em and Stink-Em.

For a time, the former mining camp on Goose Flats rivaled Tucson for the title of largest city in Arizona. On February 1, 1881, Cochise County was carved from the eastern portion of Pima County, and Tombstone became the county seat.

Tombstone's decline began in 1884, and the main cause was flooding. Seepage first began in the Tough Nut Mine in 1880. The following March, another mine hit water at 520 feet. In March 1882, a new shaft at the Grand Central began to seep at 620 feet. Before long, the silver deposits were inundated.

A group of Tombstone mine owners journeyed to San Francisco to meet with the principal investors to discuss draining the mines. They purchased a couple of Cornish engines that had been used previously at Nevada's Comstock Lode and installed them at the Contention and Grand Central. Before long, they proved highly successful, and for a time, it looked like the boom times were back again. But on May 26, 1886, there was a big fire at the Grand Central, and the intense heat melted the Cornish engine. At the same time, the price of silver fell to ninety cents an ounce. The miners began to look for new digs, and by 1890, the population had dipped to fewer than 1,900. A decade later, it was fewer than 700.

Life alternated between hard, dirty work and fun and frolic. Some would later recall that life in Tombstone was pleasant and brought back fond memories while an anonymous resident commented simply that Tombstone was "a bad town and I didn't stay long."

2

THE DUTCHMAN'S GOLD

The Arizona author Kearney Egerton called lost mines our greatest natural resources:

> They don't pollute the sky with columns of acrid smoke; or collect garbage, befoul streams, or scar the delicate hillsides with unsightly tailings. They don't cost the taxpayers a cent to maintain and equip. They require no asphalt parking lots, restrooms, or visitor centers.

Lost mines are just good, clean, cheap fun. And for the true believer, they are as real as a mermaid is to a lonesome sailor.

All you need to get started is a pick, a shovel, a map, a canteen of water and a dream. It also helps to have a cellphone and GPS. The gold is out there somewhere, just waiting for some lucky cuss to find it.

Of the hundreds of lost mines in the American West, the most famous of them all was the legendary Lost Dutchman. The Dutchman has it all, including embroidered narrations, deathbed ruminations, brooding, mysteriously named mountains, ghost Apaches guarding its whereabouts and treasure beyond any Argonaut's wildest dreams.

The Superstition Mountains were named by the Pima Indians living along the Gila River. Apache raiders would plunder their villages and then retreat to their lairs in the narrow, rugged canyons. When the Pima warriors would launch a punitive expedition against their ancient enemies, they would be lured into the mountains and never be seen again. When visitors asked what

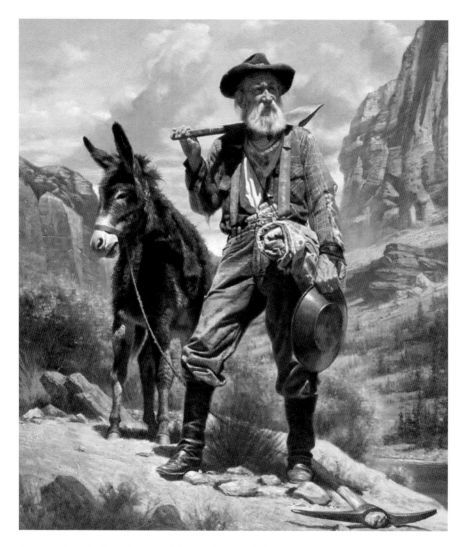

The Old Prospector, by Alfredo Rodriquez. *Courtesy of Tom Kollenborn.*

they were called, the Pima used a word for them that meant "bad medicine," and that's how they came to be called Superstition.

One of the legends says the story of a rich gold mine began in late 1845, when a party of Mexican miners was ambushed and massacred by Apache warriors as the prospectors were transporting gold from their mine deep in the Superstition Mountains.

Only one man, Don Miguel Peralta, survived the massacre, and he vowed never to return to that dreadful area. Then one night, two foreigners came

to his aid in a cantina fight in his Mexican village, and in gratitude, he decided to share his secret. The two were German prospectors named Jacob Waltz and Jacob Weiser. Miguel gave them directions to the old mine in the Superstitions, and the two set out to find their fortunes.

At first, they worked the mines without any problems, but they became increasingly aware they were being watched by the Apache. One day, Waltz went into Mesa for supplies and, when he returned, found Weiser had been murdered.

Another version of this story has Waltz killing Weiser so he could have all the gold to himself. Somewhere along the way, Waltz morphed into a sinister, steely-eyed killer who ambushed anyone who dared follow him to his secret mine. In reality, old Jacob was incapable of the violent nature attributed him by the yarnspinners.

According to legend, Waltz returned periodically when he needed to replenish his supply of gold. Some tried to follow the old Dutchman and learn where his horde of gold was located, but he always managed to elude them.

The problem with the Peralta portion of the story is it's entirely bogus. Dr. Robert Blair, author of *Tales of the Superstitions: The Origins of the Lost Dutchman's Legend*, wrote that there was a Miguel Peralta and he had a gold mine, but it was near Valencia, California. When his mine played out, he conned Dr. George Willing into paying him $20,000 for a bogus three-million-acre Spanish land grant in Arizona. Blair says the Peralta story was eventually incorporated in the Lost Dutchman's story, in a distorted version, following the renewed interest in the Lost Dutchman's mine in the 1930s.

Blair also says it's likely there was only one Dutchman, Jacob Waltz, and Weiser was created as the story grew. In some versions, Waltz is a kindly man, while in others he's a craven killer.

Another variation of the Lost Dutchman legend is Dr. Thorne's lost gold mine. This story has an army doctor treating a wounded or ailing Apache chief. In gratitude, the Apache blindfolds the good doctor and takes him on a circuitous journey into the Superstitions to a fabulous horde of gold. The doctor is told to take out as much as he can carry and then he's blindfolded again and escorted out of the area. Typical of these lost treasure stories, Dr. Thorne is never able to relocate the Apache gold.

There was a Dr. Thorne, but he was never an army doctor, nor did he work for the government. He was in New Mexico in the 1850s and claimed to have been taken captive in 1854 by the Navajo and, while in captivity, discovered a rich gold mine. He told three soldiers about his discovery in

1858, and they searched but never found the mine. This story was later incorporated into the Lost Dutchman legend.

Sometime around 1870, Waltz filed on a homestead in south Phoenix near the Salt River. Later in life, he fell on hard times and was being looked after by a kindly African American woman named Julia Thomas.

During the winter of 1891, the river ran its banks, flooding his farm and forcing the old man to seek refuge in a tree. He contracted pneumonia and, while on his deathbed, told Julia about his gold mine. He also drew a crude map.

After his death, she, along with a couple of brothers, Reiney and Hermann Petrasch, searched but were never able to find the treasure. Ironically, the trio would have crossed the very ground west of the Superstition Mountains near today's Goldfield. Just a month later, prospectors would discover rich gold deposits. Five months later, another large deposit of gold was found nearby. Over the next four years, Mammoth Mine produced some $3 million in gold.

Thomas did manage to make a few bucks by selling maps—claiming to have directions to Waltz's mine—on the streets of Phoenix for seven dollars each or whatever the traffic would bear. Julia Thomas and the Petrasch brothers returned from their futile search for the Dutchman's gold in late September 1892 and, shortly thereafter, shared their stories with Pierpont C. Bicknell, who had a fertile imagination to go along with his penchant for lost mines. This was the golden age of prevarication and he was a master. Bicknell took their story and, with a grand display of imagination, literary license and embellishment, created the legend that most are familiar with today. It provided provocative clues to the whereabouts of the Dutchman's gold and, for the first time, used the phrase "Dutchman's Lost Gold," incorporating the Weaver's Needle into the tale. He may have included the embroidered story of the fictitious Miguel Peralta.

The story was published on the pages of the *San Francisco Chronicle* in January 1895. Prior to that, there had been no linkage between the Peralta family, Jacob Waltz, the Dutchman's Lost Mine and Weaver's Needle. Bicknell seems to have woven them all into one tale.

The lack of success by treasure seekers caused interest to fade, and the story of the Lost Dutchman Mine was nearly forgotten until the summer of 1931 when a Dr. Adolph Ruth came to Arizona. He carried with him what he claimed was a map giving the location of the Peralta's Las Minas Sombreras. Ruth's story sounds similar to that of Waltz and Weiser meeting

Miguel Peralta in Sonora many years earlier. This time, Dr. Ruth's son Erwin, who was an attorney, gave some legal advice to a man named Pedro Gonzales that spared him from going to jail. In gratitude, Gonzales told Erwin about the Peralta mine and gave him some maps, which he passed on to his father, an avowed treasure hunter. Previously, Dr. Ruth had been seriously injured in a fall while searching for the fabled Lost Peg Leg Mine in California and now walked with a cane.

Ruth spent a few weeks at Tex Barkley's ranch before embarking on his treasure hunt. Barkley pleaded with him, warning the doctor against venturing into the mountains in the desiccating summer heat. Despite the warnings, the elderly, frail man went into the Superstition area in the middle of the summer and didn't come out. His dismembered body was found several months later. His skull had what might have been two bullet holes. Curiously, the maps were missing. He left a note saying he had found the mine and wrote triumphantly, "veni, vidi, vici."

To add to the intrigue, authorities determined there was no foul play and Ruth had died from heatstroke or a heart attack. It was also suggested that he'd committed suicide. Since Ruth's pistol was found at the scene fully loaded, skeptics wondered how he could have shot himself in the head twice and then reloaded his pistol.

Dr. Ruth's story made national news and spurred new fascination with the Lost Dutchman. A whole new generation of Dutchman hunters was born. About that same time, the Dons of Arizona was founded to promote and preserve the colorful folklore of the state, especially the Lost Dutchman Mine.

In 1934, Oren Arnold, a popular columnist for the *Arizona Republic* and freelance humorist from Phoenix, sat down and wrote a short book on the Dutchman titled *Superstition's Gold* that sold thousands of copies. He would later claim, tongue-in-cheek, that he was the only one who ever made any money from the lost mine.

Then, in 1945, John T. Clymenson (a.k.a. Barry Storm) took Pierpont Bicknell's tales to the next level, embellishing every legend from the Jesuits and Peralta's to the Dutchman and Weaver's Needle and publishing *Thunder God's Gold*. In 1948, the book was made into a movie, *Lust for Gold*, starring a young Glenn Ford as old Jacob. The beautiful Ida Lupino was written in to provide some romance.

Barry Storm's book did more than anything yet to perpetuate the mythical Lost Dutchman Mine. It coincided with the unprecedented growth that took place in Arizona following World War II.

Weaver's Needle in the Superstition Mountains was named for mountain man and scout Paulino Weaver. *Wiki Commons (CC BY-SA 4.0)*.

Between 1959 and 1962, a full-scale feud broke out at Weaver's Needle between Ed Piper and Celeste Marie Jones. Both were seeking the mythical Lost Jesuit treasure, and it created a contentious situation between the two camps. Jones, an African American lady reputed to be a former opera singer, carried a sawed-off .30-06 rifle and a pistol strapped to her hip. Piper went similarly armed. She believed the gold was inside Weaver's Needle and planned to drill a shaft down through the core then blow it up.

Neither seemed to be the violent sort, but both attracted an assortment of supporters who claimed to be bodyguards. A saloon in Apache Junction hung a recruiting post for each, complete with sign-up sheets. The frivolity ended when a fight broke out among the bodyguards, resulting in three deaths.

The feud ended when Piper died of natural causes in 1962, and Jones abandoned her claim and took off for parts unknown.

Since Dr. Ruth's fatal experience, many have gone into the mountains and failed to return. Some died under mysterious circumstances. Oftentimes, these seekers had to learn the hard way that the desert is a very unforgiving place. Thus far, the foreboding mountains have kept their secret.

There are a few facts about Jacob Waltz, the gold and the Superstition Mountains that are worth noting:

There's no evidence that Waltz ever cashed any gold in at any bank or mercantile business, and there's nothing about him or his fabulous gold mine in any of the newspapers prior to his death. Surely some reporter would have picked up on this. He filed only one mining claim in Arizona and that was in Yavapai County in the 1860s.

Archaeologists agree those so-called Peralta Stones are actually prehistoric native petroglyphs; many of the same images are found in other prehistoric sites. And there's no record of a Peralta ever being in the Superstition Mountains. As for any of those other maps, where's the provenance they are authentic?

The Apache legends and stories have nothing about gold existing in those mountains.

Geologists agree the area where the lost mine is supposed to be located is non mineral–bearing, nor has there ever been anything commercially mined around Needle Canyon or Black Top Mountain. Prospectors and treasure seekers have been scouring that area for more than a century, and nobody has turned up any pay dirt.

The Dutchman's gold and that of other lost mines in Arizona was pretty well summed up nearly five centuries ago by Coronado's chronicler Pedro de Castaneda, who wrote, "Granted they did not find the gold, at least they found a place in which to search."

While historians and writers refute the existence of the Lost Dutchman and the stories of buried treasure in the Thunder God's Mountains, the legends live on and the Dutchman hunters still persist.

Don't get me wrong. I love lost mines and treasure stories and have spent some time searching for a few. I grew up devouring books like J. Frank Dobie's *Coronado's Children*. For a time, I also became one of the great conquistador's children. I never found any gold—never even found a nugget—but then I'd rather have the stories than the gold.

THOSE FIGHTING EDITORS OF TERRITORIAL ARIZONA

Wherever folks wandered in the rugged wilds of the West during the second half of the nineteenth century, there remained a desire to keep up with the happenings "back in the states." Local events such as the latest political shenanigans were always a curiosity, too. Many took their politics seriously, to the degree that there were Republican and Democrat saloons and lo the poor stranger who might wander inside the wrong one and espouse his opinion.

There were no schools of journalism in those days, as evidenced by the crude language and bad spelling found in old newspaper files. Anyone with a printing press, paper, a "shirt-tail of print" and an opinion was free to start his own newspaper. It also helped to have a dogged determination to succeed in the face of mighty tough odds.

Few editors had any kind of business background, so many found themselves in financial trouble before the ink was dry on the first issue. Early editors and publishers were usually one and the same. They were difficult to stereotype. Some were torch carriers for justice, seekers of truth and champions of liberty; others were ruthless, writing with pens seemingly dipped in acid; and still others stylized their observations in a humorous, lighthearted vein. The personality of the editors, their strengths and weaknesses set the tempo and flavor of their respective chronicles. Few became wealthy, and only a handful became famous.

It was critical that an editor understand the politics of his community. Lindley Branson of the *Jerome Sun* incurred the wrath of the powerful but

secretive William Andrews Clark, owner of the United Verde Mine. When Branson tried to glean information on the wealth of the ore deposits, the copper magnate leaned on the paper's advertisers to withdraw their support. Without advertisers, the paper quickly folded, forcing Branson to leave town.

John Clum came to Arizona in 1874 at the age of twenty-three as an Indian agent at San Carlos Apache Reservation. He wanted to organize an Apache police and a court system run by the natives. He also tried to remove the army from the reservations. Clum butted heads in Washington, but he did have some successes. In 1877, Clum and his Apache police did something no army group could ever accomplish. They captured Geronimo. Ultimately, Clum resigned his post and organized a newspaper, the *Tucson Citizen*.

In 1880, Clum and his wife, Mary, were attracted to the new boomtown of Tombstone, where he founded a newspaper, declaring, "No Tombstone is complete without its epitaph." The *Epitaph* is still in business, and it is the oldest continuously published in Arizona.

The irrepressible Clum became town mayor, running on a law-and-order platform. Once elected, he organized a vigilance committee. Then things began to unravel. His wife, Mary, died, and the Cochise War broke out between the law-and-order crowd and the laisses-faire political element. As editor of the *Epitaph*, Clum had to call off his war with the corrupt Cochise County Ring after members of that group bought controlling interest of the paper and forced his resignation. On one occasion, Clum barely escaped with his life when assassins fired on the stagecoach in which he was riding.

Most of these fighting editors took delight in exposing political skullduggery, especially if it was perpetrated by a faction of politicos with opposing views from the newspaper. During Tombstone's heyday, J.C. Bagg, editor of the *Prospector*, was sentenced to three hundred days in the county jail for exposing political corruption at the county level. Unfortunately for editor Bagg, one of the culprits he exposed was the judge who presided over his case.

News and events, especially those of a political nature, were spiced with a great deal of editorializing, much of it libelous and laced with raw vitriol. Many a newspaperman became a one-man chamber of commerce for his community, and one of the most notorious was Prescott's John Marion. The new town and territorial capital was not yet three years old when Marion became editor of the *Miner*. Bands of marauding Yavapai Indians preyed upon Prescottonians within sight of town. Marion's predecessor, Emmer Bently, had been ambushed and killed in Skull Valley.

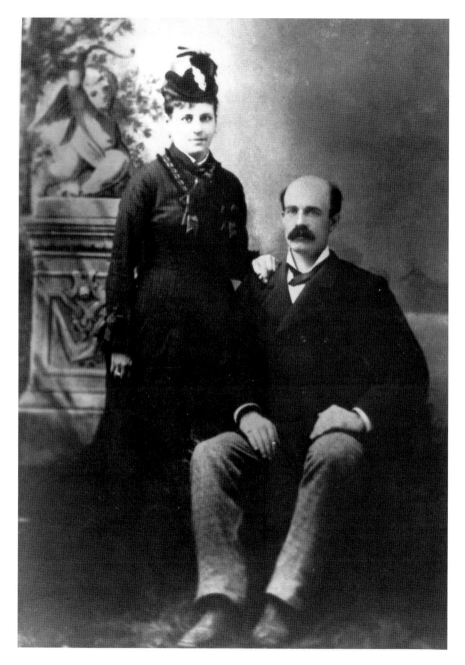

Apache agent John Clum was editor of the *Tombstone Epitaph* during the Cochise County War. He's pictured here with his wife, Mary. *Courtesy of Scottsdale Community College.*

Mincing neither words nor opinions, Marion was the most vociferous of Arizona's editors in decrying the atrocities in the territory. On January 22, 1870, he published a list giving dates and location of white men bushwhacked by Indians around Prescott.

Marion didn't reserve all his vitriolic wrath for Indians, and he had no equal when it came to abusive acupuncture. When Tucson took the capital away from Prescott in 1867, Marion blamed territorial governor Richard C. McCormick, accusing him of engineering the hijacking of the capital in exchange for Pima County supporting his appointment as territorial delegate to Washington. John Wasson, editor of the McCormick-owned *Tucson Arizonian*, took exception to Marion's diatribe, and responded in a mildly worded editorial: "[T]he *Miner* has been more filthy than usual."

Marion quickly retaliated:

> *So says the liar, affidavit man, scavenger, scullion and valet for McCormick and Company. We dare this abominable beggar to show where we have been filthy. But this is a way thieves and blackguards have for drawing attention from their own foul deeds and he would like to shift the odium to some decent man's shoulders. Black dog, to your foul kennel.*

Marion also took exception to what he considered high-handed politics on the part of "Slippery" Dick McCormick, saying that

> *through ignorance of baseness of purpose, McCormick has, for the last two years, usurped and used power vested solely in the legislature, and, squabbling the records of various counties....his littleness* [McCormick stood only five feet, five inches], *who by soft soap and flunkeyism, has wormed his way into the gubernatorial chair of a territory he has helped to impoverish.*

Another editor who felt the stinging wrath of Marion's acrimonious pen was Judge William Berry, editor of the *Yuma Sentinel*. Marion and Berry had been friends during Prescott's early days. Although Berry was a practicing attorney, the title "judge" was honorary. One of the judge's character weaknesses was an indulgence in strong drink, something Marion capitalized on in their long-standing feud. Marion questioned Berry's right to the title of judge, although he did concede that the editor of the *Sentinel* was a good judge of bad whiskey.

Rivalries between territorial editors were epic, especially during Marion's time, but few ever got the best of the fiery editor of the *Prescott Miner*. His verbal harangue, colorful and bombastic, sold newspapers. One of his self-effacing editorial comments sums up his tumultuous life as a fighting editor: "They tried to get my scalp, both the Injuns and the white man, but damn 'em, I'm still here."

Marion was also a hardcore Democrat come hell or high water. This was borne out during an election for county attorney, when he stubbornly supported Charlie Rush, the Democratic candidate for territorial district attorney, despite the fact that Rush had run off with Marion's wife.

4

A PREACHER COMES TO
HELLDORADO

During the early days of life in Tombstone, the main diversion was playing cards, but that soon changed as the business district developed. Folks drank, gambled, frequented bordellos, lied, bragged and fought. And they went to church. The town boasted four churches: Catholic, Episcopal, Presbyterian and Methodist.

George Parsons arrived in Tombstone in February 1880, and on the first Sunday he was in town, he noted in his journal, "I went to church this A.M., hearing one had just started and heard the young minister, 'Mac' McIntyre by name, in a tent. Seats on boards resting upon boxes. Good attendance considering."

A few weeks later, he wrote, "Hard work for him to preach on account of dance house racket in rear....The place is rather a poor one for divine service."

Nobody was shunned from attending church. Even the shady ladies would attend church before departing for the district or saloons to ply their trade.

Likewise, the men thought nothing of stopping by the saloons and having a few drinks before heading to church.

Ominous clouds hung over Tombstone the morning of January 29, 1882, as the Sandy Bob Stage rambled into town. The gray sky gave warning of a fast-approaching snowstorm. The passengers arriving that morning, with one exception, were typical—a military officer on his way to Fort Huachuca, an elderly Jewish peddler who told funny stories, a self-styled millionaire out to make another fortune and a tall, strapping twenty-five-year-old man dressed in a rumpled eastern-cut suit, named Endicott Peabody, who had

come to serve a six-month ministry to the Episcopal Church.

Following a seven-day trip by rail from Boston to Benson, Arizona, he bought a two-dollar ticket and took the Sandy Bob Stage south some twenty-four miles to Tombstone.

Peabody stretched his lanky frame and took his first look at the notorious silver camp, a place opined by a fellow Bostonian as the "rottenest place you ever saw."

No wild shootouts or street brawls greeted the young easterner. Because of the town's raucous reputation, he expected the worst. Instead, he was struck by the lack thereof by the locals. His arrival in Helldorado was just three months after the famous street fight near the O.K. Corral, where the Earp brothers and Doc Holliday gunned down Billy Clanton and the McLaury

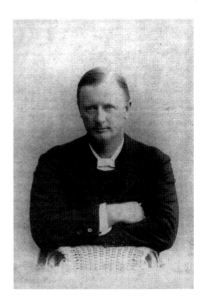

Endicott Peabody arrived in Tombstone in January 1881, just after the Gunfight at the O.K. Corral. *Courtesy of Arizona Historical Foundation.*

brothers. Just a month earlier, the Cowboy crowd had ambushed and nearly killed U.S. Deputy Marshal Virgil Earp. On March 18, Morgan Earp would be assassinated in Hatch's poolroom. The feud between the Cowboys and the Citizens Safety Committee and their enforcers, the Earp brothers, was at its height.

Peabody checked into the Grand Hotel, located on Allen Street, the town's "Barbary Coast," and that's where the church reception committee found him, pondering his tiny temporary quarters, which were well-ventilated thanks to several broken windowpanes. The committee members apologized for their tardiness, blaming it on a card game that ran into overtime. They hustled the young parson off to more suitable environs. Peabody was beginning to understand why his predecessor, Reverend Talbot, had remained in Tombstone for only two months before hastily departing.

Reverend Peabody preached his first sermon on February 5. The young minister wasted little time organizing his little congregation. The Episcopal church burned down during the town's first big fire on June 22, 1881, taking with it the church's building fund, so services were held in

the courtroom of the Miners Exchange Building until more funds could be raised.

Tombstone opened its arms and its pocketbooks to the young preacher from Boston. Over one hundred attended his second service, and a record twenty-five dollars was deposited in the collection plate.

Peabody set about raising funds for a new church. His favorite haunts to seek contributions were the saloons and gambling houses. One time, he walked in on a group of the town's merchants engaged in a game of poker and asked for a donation. On the table was a pot of more than $1,000. One player handed over $150, and the other players followed suit. Other times, he'd causally walk in, pass the hat and walk out a few minutes later with a hat full of money. Should anybody question the dubious source of the money, Peabody would reply, "The Lord's pot must be kept boiling, even if it takes the Devil's kindling wood."

Among the other generous contributors to the church building fund were the working girls and madams on Tombstone's tenderloin.

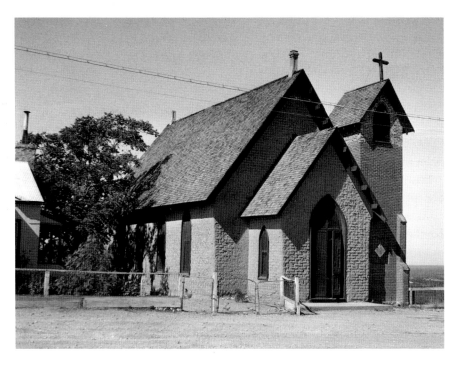

St. Paul's Episcopal Church, the oldest Protestant church in Arizona. *Courtesy of Arizona Historical Foundation.*

Not long afterward, the Gothic Revival–style St. Paul's Episcopal was erected on a lot on the corner of Safford and Third Street that had been sold for $5. On June 18, 1882, the church, which cost $5,000, had its first service. The church stands today as the oldest Protestant church in Arizona.

Before arriving in Tombstone, the Reverend Endicott Peabody of Boston had attended school in England, where he was an outstanding athlete. He graduated from Trinity College at Cambridge in 1880 before returning to the United States, where he entered a three-year program to train as a minister. He left after only three months to accept a job to reestablish an Episcopal church in Tombstone. His friends liked to say the town's notorious reputation and foreboding name provided enough inspiration for the venturesome lad to go forth into the wilderness after only three months' training.

Peabody might have had a formal eastern upbringing, but he quickly won the respect of Tombstone society in which he mingled.

Among the reverend's friends were Wyatt Earp and his brothers. Some sixty years after his arrival in Tombstone, Peabody reminisced that, in his opinion, the Earps were honorable men who were trying to rid the town of its lawless elements. He was horrified at some of the political skullduggery that existed in Tombstone. He once wrote to a friend that corrupt politicians were too busy stealing the public money to deal with the lawlessness in Cochise County.

After Morgan Earp's murder, there was talk of lynching. Peabody made some unusual remarks for a proper parson: "I really think that an example of frontier justice…would be a good thing, for the place is full of desperadoes who hold the lives of others and themselves very cheap!"

Peabody's superb athletic ability, more than anything else, won lasting respect from the Tombstone citizenry. He organized the town's first baseball team and was one of its star players. He also was vice president of the Tombstone Baseball Association.

Tombstone competed against teams from Tucson, Bisbee and Fort Huachuca. Competition was fierce and betting was heavy, as communities staked prestige and pride on the outcome. Since the miners worked a six-day week, the Sabbath was reserved for baseball—that is, until the arrival of Endicott Peabody. To find an unbiased umpire to officiate these contests and not be intimidated by the angry crowds was next to impossible. Reverend Peabody was the only man in the area who commanded enough respect to act as chief arbiter. This he did—for a price. The players must first attend church. It's quite doubtful if the players felt out of place, as the magnetic

personality of the parson attracted Tombstone's wide gamut of frontier society, ranging from gamblers, prostitutes and saloonkeepers to miners, merchants and the society of the upper crust.

The *Tombstone Epitaph* spoke for most when it wrote admiringly of him: "Well, we've got a parson who doesn't flirt with girls, who doesn't drink behind the door and when it comes to baseball, he's a daisy!"

Peabody also was a first-class boxer, and of all the sporting events staged in a typical mining camp, pugilism was the one that garnered the most respect from the miners. Not only was this proper Bostonian the kind of man who was not too uppity to drink a bottle of beer in public with the common working man, but he also could handle his fists with the best of them. More than once, he duked it out in the boxing ring, and he never lost a match. One time, he was matched with the local Methodist minister, Mac McIntyre, who was considered a pretty good pugilist. Peabody handed his rival a sound thrashing. He also handily defeated the local miner's champion, something that made him the undisputed hero of the town.

The *Tombstone Nugget* wrote: "Talk about muscular Christianity, we overheard a miner yesterday say, upon having the Episcopal minister pointed out to him, 'Well, if that lad's argument was a hammer and religion a drill, he'd knock a hole in the hanging wall of skepticism.'"

Billy Claiborne, a self-styled "Billy the Kid," who was, in reality, an ignominious member of the Cowboy or rustler element, is best remembered by western historians as the brash young man who talked tough, then hightailed it for cover when the shooting started at the fight behind the O.K. Corral.

Billy usually hung out in the town of Charleston, a few miles west of Tombstone and a raucous burg that made the Town Too Tough to Die seem tame in comparison. On one occasion in that town, Reverend Peabody preached a sermon on the "eleventh commandment": "Thou Shalt Not Covet Thy Neighbor's Cattle." When word reached Claiborne, the rustler sent word that the next time Peabody set foot in Charleston he would attend and make the preacher "dance" to the music of his roaring six-gun. Peabody sent word that he would be in Charleston in two weeks and would look forward to dancing with Billy. Billy Claiborne failed to keep the appointment.

Another member of the Cowboys took umbrage at the preacher's remarks and threatened to tar and feather him. Peabody suggested that if they were going to make a fight of it, they should build a boxing ring and charge admission, the money going to the local orphanage. A large crowd gathered for the event, and for three rounds, the challenger came at the preacher with

fists flying. None of his windmill punches landed, as Peabody backpedaled around the ring. Finally, the cowboy was plum worn out and dropped his arms. Peabody then delivered a roundhouse blow that laid him out cold. The young minister had gained a whole new respect from the rough-and-ready Tombstonians and the Episcopal Church kept increasing.

Tombstone gladly embraced the young minister, but his notes tell of how much he missed his home in Massachusetts. Unfortunately, Peabody didn't remain long, returning to Boston on July 17, six months after his arrival. Parsons noted in his diary, "It will not be easy to fill Peabody's place."

Peabody returned to the Episcopal Theological School, graduating in 1884. The following year, he was ordained and took a wife. He then decided to combine the ministry with teaching, and with financial aid from the folks in Boston, he established the famed boys' prep school at Groton, Massachusetts. His stated mission was to prepare young men not for college but for life. One of his students was a bright young man from New York named Franklin Delano Roosevelt. Peabody later officiated his former pupil's wedding to Eleanor.

After Peabody left Tombstone, the legend of the "two-fisted" preacher grew, much like that of the legendary gunfighters of the Wild West. He found many parts of the myth were hard to dispel. It's likely the overflowing crowds that attended church were attracted more by the charisma of the man than a desire for religious learning. For whatever reasons, they never forgot him. When the parson returned to the Town Too Tough to Die to preach a sermon in 1921 and again in 1941, his old flock traveled from all over the state to be present for the occasion.

Tombstone also had a lasting effect on Peabody as well: the generosity, independence, rugged individualism and honest determination he observed there. Years later, he wrote of these people: "They could almost fairly be so described (the good old days in Tombstone) for they helped one discover the ideals and generosity which are latent in our people....It has taught me that in America we are all just 'folks.'"

In 2007, following the 125th anniversary of the building of St. Paul's, Peabody was added to the Episcopal Church's liturgical calendar, with November 17 becoming the feast day of Endicott Peabody. He is thus regarded as the patron saint of the Episcopal Diocese of Arizona and venerated as one of its most important missionaries.

The Peabodys are one of Massachusetts's most illustrious old families, dating back to colonial times. Endicott's son Malcomb E. Peabody was Episcopal bishop of Central New York.

Athleticism also ran in the Peabody family. Grandson Endicott "Chub" Peabody graduated from Harvard in 1942. He was an All-American defensive lineman for Harvard and later inducted into the College Football Hall of Fame. During World War II, he was a navy lieutenant and received the Silver Star for gallantry during action in the Pacific aboard the USS *Tirante*. In 1962, he was elected governor of Massachusetts.

5

KIT CARSON

THE MAN AND THE MYTH

In recent years, a few modern-day revisionists have done much to malign the great soldier, scout and explorer Christopher "Kit" Carson. Carson was the real deal, and it's a travesty to the memory of a great American that lies, distortions and misinformation have cast a dark shadow on his rightful place in American history.

Historian William Manchester termed it "generational chauvinism": "The judging and condemning of events and figures from past eras by the standards of our own time. Each generation looks back at the past and re-interprets its history to suit their own values and needs."

At the age of sixteen, Carson ran away from his job as an apprentice at a saddlery in Missouri and joined a party of traders heading down the Santa Fe Trail. By 1831, under the tutelage of the famed mountain man Ewing Young, Carson had "won his spurs," becoming a first-class free trapper with a reputation among his fellow trappers for trustworthiness, courage and honesty.

Like many trappers, he easily integrated into Indian life. At the age of twenty-five, he married an Arapaho woman who bore him a daughter. She died at the birth of their second girl.

Carson found himself a widower with two young children. The fur trade was in steep decline, and his days as a fur trapper were over. He hired out as a hunter at Bent's Fort on the Arkansas River and soon took a pretty Cheyenne woman for a wife, but she was restless and divorced him Cheyenne-style by dumping all his belongings outside their tipi. Then his younger daughter died when she fell into a pot of boiling water.

In 1842, he went to St. Louis to place his daughter, Adeline, in a school. He was returning on a Missouri river steamboat from St. Louis when he made the acquaintance of John C. Frémont, a young army lieutenant with the Army Corps of Topographical Engineers, who was about to leave on an expedition to map and explore the Rocky Mountain West. Frémont would eventually go down in American history as "The Great Pathfinder," but at the moment, he was just another ambitious soldier. He was also the son-in-law of the powerful U.S. senator from Missouri Thomas Hart Benton.

Frémont was looking for a guide, and Carson modestly admitted he had "been some time in the mountains." After checking out Carson's credentials, Frémont hired him, and on that first expedition, they would map what would become the storied Oregon Trail. It was a fortuitous chance meeting for both men. Had there been no John C. Frémont, there might never have been a Kit Carson and vice versa.

Carson worked as a guide and scout on all three of Frémont's expeditions for the Corps of Engineers. In reality, Carson was the Great Pathfinder's pathfinder. Frémont's glowing reports and lavish praise for his guide made Carson a national hero. The explorer, with the help of his wife, Jessie, wrote splendid reports about all his scouts, including the legendary Joe Walker, but it was Carson who captured the fancy of the American public.

Frémont's stories about Carson's heroic feats also brought national attention in the wrong places. Some seventy pulp novels featured Carson without compensation or his permission. Sensationalized stories portrayed him as a blood-and-guts, rip-snorting giant of a man who slaughtered Indians by the dozen. There wasn't a grain of truth in the action-packed thrillers, but easterners devoured them.

Had they met the real Kit Carson, they would surely have been disappointed. This so-called fire-eating giant of a man stood only five feet, five and a half inches, weighed just 140 pounds and was illiterate. His quiet, unassuming manner, stoop shoulders, short stature and gentle voice did nothing to reveal the dauntless courage he possessed.

Charles Averill's pulp *Kit Carson, Prince of the Gold Hunters* depicts him as a mass killer of Indians and credits him as "the man who discovered gold in California." On another pulp, he was shown on horseback holding a beautiful, scantily clad woman with one hand while fighting off Indians with the other. When the cover was shown to him, he glanced at it and modestly replied, "That thar may be true but I hain't got no recollection of it."

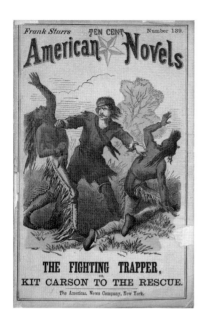

Dime novel *Kit Carson to the Rescue*.
Courtesy of Scottsdale Community College.

In February 1843, he married the beautiful Maria Josefa Jaramillo, the youngest daughter of a prominent Taos family and eighteen years his junior. He quickly embraced the Mexican culture, converted to the Catholic faith and spoke Spanish in their home. He was settling into life with Josefa when his country came calling again.

In 1846, while on a third expedition with Frémont, at his urging, Carson took part in the short-lived California Bear Flag Revolt. He guided General Stephen Watts Kearny's Army of the West across Arizona and into California, where they were attacked by Andrés Pico's Californio lancers mounted on fine horses at San Pasqual, near San Diego. That night, the Army of the West found itself surrounded and under siege. Carson, along with Ned Beale (the man who would lead the famous camel survey across northern Arizona ten years later) and a Delaware Indian scout whose name has been lost to history, slipped through the enemy lines and walking barefooted some thirty miles over rocks and cactus, reached San Diego and brought a relief force to rescue the Americans.

After the war, Carson returned again to his home and family in Taos. After all this action and adventure, all he really wanted out of life was to spend time with his beloved wife and family. By the end of 1848, they'd been married six years and he'd only been home some six months. It wouldn't be long until he was called to action again.

In late October 1849, Carson was needed to scout for a company of dragoons in pursuit of Jicarilla Apache raiders along the Santa Fe Trail. A Missouri trader named James White, his wife, Anna, and their infant daughter were attacked by the raiders. White was killed, and his wife and child had been taken captive.

On the twelfth day, the dragoons spotted the Apache camp, but the warriors scattered. When they reached the camp, they found the body of Mrs. White. She'd only been dead a few minutes. Her child was never found. Among her possessions was the popular dime novel *Kit Carson, Prince*

of the Gold Hunters, in which Kit Carson saves a beautiful woman from death at the hand of a band of Indians. When the story was read to him, he muttered angrily, "Throw it in the fire!"

He was deeply troubled by the fact that this woman was hoping the legendary Kit Carson would come to her rescue; unlike in the dime novels, he got there too late. The incident haunted him for the rest of his life.

In 1853, he became the Indian agent to northern New Mexico, a position he held until the Civil War broke out in 1861. During his tenure, he won respect as a staunch defender of Indian rights.

The following year, Carson was called to duty when New Mexico was invaded by a Confederate force from Texas. He was commissioned a lieutenant colonel in the Union army and led the New Mexico Volunteers at the Battle of Valverde. Although many of the Union soldiers faltered, Carson's men fought gallantly.

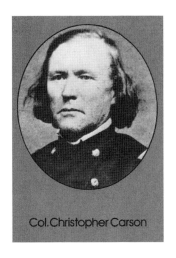

Col. Christopher Carson

Although he was illiterate, Kit Carson rose to the rank of brigadier general in the army. *Courtesy of Scottsdale Community College.*

The years of hard campaigning had taken a toll on his health, and in early 1863, Carson tried to resign from the army. However, his bravery, knowledge of the land and leadership skills had caught the attention of General James Carleton. Carleton, renowned for his hatred and extermination policy toward Indians, refused to accept Carson's request. Instead, Carson was ordered to lead a campaign against the Navajo at Canyon de Chelly. His orders from Carleton were terse: "Kill all the men."

Contrary to Carleton's orders, only twenty-three Navajo warriors died during the 1864 campaign at Canyon de Chelly. Carson's scorched-earth sweep through the canyon broke the Navajo spirit, and some eight thousand surrendered. Carson's work was finished, and he returned to Taos. Carson played no role in the appalling events that followed.

The Navajo were taken on the infamous Long Walk to Fort Sumner, a reservation Carleton had selected on the Pecos River in New Mexico, nearly five hundred miles from Canyon de Chelly. During the trek, they were subjected to brutal treatment by their longtime enemies, the New

Mexicans. Several hundred died on the walk, while others, mostly women and children, were abducted by slave hunters from neighboring tribes.

The million-acre reservation at Bosque Redondo turned out to be a disaster. Cutworms decimated their corn crop, and the army was forced to provide food at an annual cost of $1.5 million.

In May 1868, General William Tecumseh Sherman visited the reservation to investigate mistreatment of the Navajo and found their conditions deplorable. He offered to move them to Oklahoma, but they chose instead to return to their beloved sacred lands in the Four Corners area. Their wishes were granted in the Treaty of 1868.

In November 1864, Carson, his health deteriorating, was called to duty to lead another campaign, this time in the Texas Panhandle against the Kiowa and Comanche at Adobe Walls. His small force found itself facing some three thousand Comanche and Kiowa warriors. After a fierce five-hour battle, Carson's forces, running low on ammunition, retreated. Despite the heavy fighting, his casualties were light. Now a brigadier general, he returned to Taos, having led his last campaign.

His beloved wife, Josefa, died on April 23, 1868, from complications after giving birth to their eighth child. Carson, his heart and health broken, died a month later at Fort Lyon, Colorado.

THE ESCALANTE

FRED HARVEY'S FABULOUS HOUSE

Nothing remains at the site today except a few shards from the tile that used to grace the floors of the elegant building, but at one time the Escalante on the Santa Fe Railway in Ash Fork was billed as the best Harvey House west of Chicago.

The name was in keeping with the Harvey tradition of naming establishments after Spanish explorers. Silvestre Escalante was an eighteenth-century Franciscan padre-explorer who first journeyed into Arizona in 1776.

The Atchison, Topeka and Santa Fe began building its main line west from Albuquerque in 1880, and by 1883, the railroad had stretched its steel ribbons across Arizona and was heading for California. With the completion of the Santa Fe, Prescott and Phoenix Railroad in 1895, the capital city of Phoenix was linked by rail at Ash Fork with the Santa Fe main line. Ash Fork is still central Arizona's only direct link by rail to the main line.

Before the days of railroad dining cars, passengers were forced to eat in hash houses wherever the train happened to stop. The food was terrible, and the service was worse. Passengers would place their orders, and just about the time the food arrived, the conductor would shout "All aboard!"

Meal tickets were sold to the passengers by the conductor, and it's likely he got a kickback when the meal was not eaten. Thus, the same meal could be sold more than once. Not only were these conditions deplorable for passengers but they also were worse for locals, who had to deal with such conditions on a permanent basis. Travelers were at the mercy of the

Ash Fork in 1926, the year Route 66 was christened. *Courtesy of Scottsdale Community College.*

local restaurants and hotels. It took a gentleman from England named Fred Harvey to bring real cuisine to the American Southwest.

After experiencing some of the eating conditions along America's rail lines, Harvey approached the Santa Fe Railway in the 1870s with the visionary idea of providing passengers with attractive surroundings, superior service and, above all, good food. The railroad company accepted his proposals enthusiastically, for food service had been one of several serious problems plaguing all the railroads at this time. The Santa Fe agreed to build and supply the buildings along the line, including shipping food, furnishings and personnel free of charge. In addition, Harvey was to receive all the profits from the venture. Evidently, the Englishman was not only a good restaurant man but a shrewd bargainer as well.

The first Harvey House opened for business in Topeka, Kansas, in the spring of 1876, and it was an immediate success. French chefs were hired away from prominent restaurants in the East and paid handsome salaries. In at least one instance, a Harvey House chef was making more money than the president of the local bank.

During the next twenty years, Harvey opened his Spanish-style restaurants and hotels at one-hundred-mile intervals along the Santa Fe line from

Kansas to the Pacific coast. It was said the Harvey Houses were spaced at that distance so they would keep "western traffic from settling in one place where Harvey served his meals."

The Fred Harvey Company trained all its own chefs, and the great majority were French and German.

In the early 1900s, one could be served a breakfast consisting of cereal, fruit, eggs atop a steak, hash browns and six large hotcakes with butter and maple syrup, topped off with apple pie and coffee, for fifty cents. Dinners went for a quarter more and included a fancy gourmet dish or wild game.

Eventually, Arizona would have five Harvey Houses: Winslow, Williams, Seligman, Kingman and the grandest of them all, Ash Fork's Escalante.

Ash Fork's first Harvey House was a wooden structure located on the north side of the tracks facing the Parlor House Saloon, but on June 17, 1905, a fire destroyed the depot, a hotel, a restaurant and the water tower in the heart of the business district. Railroad officials promised they would build a new Harvey House of steel and concrete much better than the original. After the fire, the old depot, built with flagstone blocks, was moved over to Route 66 on the west end of town, and today it is the award-winning Ash Fork Route 66 Museum.

In March 1907, the luxurious Escalante—built at a cost of $115,000—opened for business. The restaurant had a beautiful crystal chandelier–lighted dining room. Silver, linen tablecloths and crystal made up the table settings. No man was allowed to enter the dining room in shirt-sleeves, but the manager kept a supply of coats on hand as loaners. An open balcony was extended along the front of the building, and a covered screened porch stretched across the back. The grounds were beautifully landscaped with fountains and flowers. On the east side was a cactus garden. A brick walkway lined the front of the building. The luxurious hotel and restaurant operated a newsstand, curio shop, barbershop and depot.

The Escalante had all the opulence and conveniences of a first-class hotel in an eastern city, including telephone, hot and cold running water, electric lights, baths and steam heat.

It wasn't just the excellent food that attracted the people, especially men, to these Harvey Houses; the boss man added one more ingredient, the feminine touch. In a land where women were scarce, Harvey introduced the Southwest to a wholesome group of young ladies, the likes of whom had not yet been seen in that region.

They were a welcome sight to the lonely cattlemen, cowboys, miners and railroaders—not to mention prominent single businessmen. Few stayed

Indian Room at the Escalante Hotel. Fred Harvey was instrumental in introducing tourists to the arts and crafts of the Hopi and Navajo Indians. *Courtesy of Ash Fork Route 66 Historical Museum.*

single long. Cowboy humorist Will Rogers quipped, "Fred Harvey kept the West in food and wives."

The Harvey Girls were recruited in the eastern part of the country through newspaper advertisements that read: "Young women 18 to 30 years of age, of good character, attractive and intelligent as waitresses in Harvey House Eating Houses in the West. Good wages with room and meals furnished."

Career choices for women were quite limited in those days. For a young woman hoping to escape from the hometown doldrums or one with hopes of acting out some romantic role and adventure, the ad sounded like a dream come true.

Harvey paid good wages—seventeen dollars a month—and offered free room and board. They had to be in bed at 10:30 p.m. on weekdays and 11:30 p.m. on Saturday. The dorm had a house mother to look after the ladies and keep them from trying to sneak out after hours. This author has it on good authority a ladder leading up to the dorm was hidden in some vines.

The women signed a one-year contract, promising not to get married until the contract was up, but no sooner did they step down from the train than the marriage proposals came rolling in. "The pretty ones took about a day," said one old-timer, "while the ugly ones took three days at most."

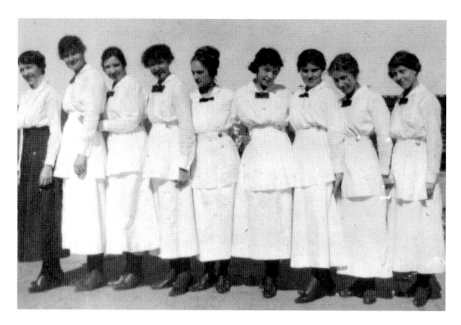

The Harvey Girls relaxing between trains at the Escalante Hotel. *Courtesy of Ash Fork Route 66 Historical Museum.*

The Escalante Hotel in Ash Fork was one of Fred Harvey's crown jewels. *Courtesy of Ash Fork Route 66 Historical Museum.*

A Harvey Girl could usually have her pick of the most prosperous gentlemen in town. Harvey never held them to the non-marriage clause—in fact, like a proud father, he'd even throw a wedding party in the bride's honor. The turnover of help was never a problem, as there was always a long waiting list of applicants anxious to go west and work as a Harvey Girl. It was said Harvey tried to hire plain-looking girls because they were more likely to fulfill their contracts. According to one observer, "The plain ones seemed to get in less trouble."

Competition from roadside ventures along Route 66 caused the Escalante, a familiar landmark since 1907, to close down hotel operations in 1951. Two years later, the restaurant closed. Despite local residents' efforts to save it, the stately Escalante was demolished in 1968.

In 1946, my father hired out as a fireman on the Santa Fe, and a year later, we moved to Ash Fork. World War II was over, and Americans were on the move. Route 66 was still a narrow two-lane highway. Freight and passenger trains pulled by steam locomotives rolled through town daily. Engines called helpers were hooked up to the rear of the eastbound trains to push them up the steep thousand-foot grade to Williams.

The Escalante was the crown jewel of the town. People used to drive all the way from Prescott to dine there. During the Korean War, my uncle built me a shoeshine box, and when a troop train rolled in, I earned a couple of dollars a day shining shoes for a nickel apiece beneath the Escalante's grand arches. It was a great place to be a kid in the early 1950s.

THE HONEYMOON TRAIL

YOUNG LOVE

There were many trails that crossed Arizona in the early days, including the Butterfield Overland Stage, the Gila Trail and the Beale Camel Road, and those all trekked east to west. But there was another important trail that went north to south. That one isn't as well known as the others, but it was familiar to the early Mormon settlers who began arriving in Arizona from Utah beginning in 1877. It was called the Hamblin Trail for Jacob Hamblin, who is remembered today as the "Buckskin Missionary" or the "Mormon Daniel Boone." The trail led across the Arizona Strip, up and over the Kaibab Plateau past the Vermillion Cliffs, across the Colorado River at Lee's Ferry, down Moenave Wash to the Little Colorado River and around today's Winslow and Holbrook.

From there, Mormons would eventually spread all across the land, settling in Eager, St. Johns, Mesa, Safford and St. David and even into northern Mexico.

A rich but not as well-known part of the story of the Hamblin Trail concerns an important journey for young couples who made a return trip up the trail. Arizona didn't have a Mormon temple until 1926, so young couples had to be married in local wards. Most wanted to have their marriage vows sanctified in the temple, and the nearest one was several hundred miles away at St. George, Utah. It was an arduous journey that could take several weeks.

The young couples had to backtrack up the Hamblin Trail by wagon through the rugged mountains of central Arizona to the Little Colorado

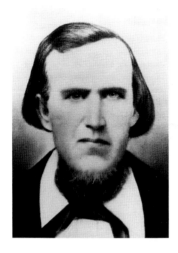

In 1877, Jacob Hamblin led the first group of Mormon colonists along a trail he pioneered from Utah to Arizona. He's remembered today as the "Mormon Daniel Boone." *Courtesy of Arizona Historical Foundation.*

River at Sunset Crossing, today's Winslow, then north to Lee's Ferry on the Colorado River and west to St. George. The wagons could make at best fifteen miles a day. Some couples were able to make the long journey right after their marriage; however, it was not uncommon for couples to have to wait for months, even years before they could make the trek.

After the ceremony in St. George, the happy couple rested the stock a few days, loaded up on supplies, hitched up the team and headed back down the trail to Arizona.

For those who made the journey, despite all the bumps and grinds, it provided countless couples with a lifetime of fond memories of starting out life together on the Arizona frontier.

Yep, the history books call it the Hamblin Trail, but to those young couples who made the journey back to Utah to seal their vows, it would always be the "Honeymoon Trail."

A few years ago, I interviewed an elderly couple who'd made the journey many years before. Aware of the trials and tribulations they encountered, I observed that if newlyweds could stick together through a trip like that their marriage could handle anything life threw at them.

They smiled and agreed. Then I asked the wife: "Did the idea of divorce ever occur to you on the trip?" With an impish grin she said, "I never considered divorce…but I did think about murder once or twice."

THE GUNSHOT PHYSICIAN

On a chilly evening in Tombstone, a dark, shadowy figure crept up the stairs behind the Crystal Palace Saloon. Inside, the raucous sounds of laughter mixed with the whirling of roulette wheels and music coming from a rinky-dink piano.

The man reached the top of the stairs and looked around. Deciding his approach had gone unnoticed, he struck a match, and in the flickering light, he saw a sign. In a low whisper, he sounded out the words, "George Goodfellow, M.D." He opened the door and quietly slipped inside. The sound of snoring drew him to the far corner of the room. He approached the sleeping figure. It would not be a good idea to rouse the sleeping doctor without being cautious. Doc Goodfellow was no ordinary physician—he was a well-known pugilist. He was more than a match for any cowboy or hard-rock miner.

The intruder reached out and gently tugged at the sleeping man's foot. "Wake up, Doc," he said. "Curly Bill needs ya over in Galeyville. He's been shot bad."

Doc Goodfellow was awake in an instant. He knew this was no ordinary house call. Curly Bill never sent one of his men all the way to Tombstone unless the matter was grave. Also, the outlaws always paid for their gunshot bills with hard cash.

The frontier was a great place for a doctor to practice—and that's what many of them did, practice. In 1880, Tombstone, a town of two thousand, had a dozen doctors, but eight of them didn't have licenses. It was a place

where they could improvise at will, working without the same restrictions and restraints as their eastern colleagues. Oftentimes they had no choice but to experiment if their patients were to have any chance at all.

Doctors treated all kinds of ailments, from broken limbs, gunshot and stab wounds to rattlesnake bites and scorpion stings. The most common injuries involved explosives, wagons and horses.

They delivered babies and fought smallpox, pneumonia and diphtheria. At times, they had to be creative. One wrote, "I slit the throat of the child choking with diphtheria, opening the windpipe and kept it open with fishhooks."

Most of the time, surgery was performed at the scene of the accident. There was total lack of cleanliness, due mostly to lack of awareness. Little was known about germs. Carbolic acid was usually the sterilizer, but strong whiskey also worked. But anesthetics and sterilization were rare or nonexistent. One told of operating on a tree stump while his patient was sprawled over a whiskey barrel. One hand did the cutting while the other shooed away the flies. Another used his two-hundred-pound office boy to sit on the patient's head to keep him still during the surgery.

One of the most famous frontier practitioners was Dr. George Goodfellow. He gained notoriety shortly after he hung up his shingle on the second floor of the Golden Eagle Brewing Company. The building burned soon after in the big fire on June 22, 1881, and was rebuilt as the Crystal Palace. It also housed the office of U.S. Deputy and Town Marshal Virgil Earp.

Doc came to Arizona as a contract surgeon for the army at Fort Whipple at Prescott and from there to Fort Lowell in Tucson. Finding army life dull, he set out for the boisterous new boomtown of Tombstone, arriving in 1880.

Tombstone was a great location for practical experience, and before long, Goodfellow was known nationwide as the "Gunshot Physician" for the articles he published on treating them. He concluded that a gut shot from a Colt .45 was invariably fatal. He wrote, "Gunfighters; maxim is 'shoot for the guts,' knowing that death is certain, yet sufficiently lingering and agonizing to afford a plenary sense of gratification to the victor in the contest."

Doc Goodfellow had the distinction of being the first physician known to operate successfully on abdominal gunshot wounds and was praised as the first to perform a successful perineal prostatectomy in 1891.

During the big fire in June 1881, Tombstone chronicler George Parsons was critically injured while tearing down a balcony to prevent the fire from spreading. A piece of wood flattened and deformed his nose. Doc skillfully

reconstructed Parson's nose then refused payment because George was injured performing a public service.

Doc Goodfellow pioneered "outdoor care" in Arizona's dry climate for victims of tuberculosis. He performed the first appendectomy in the Arizona Territory.

Few doctors who entered Arizona during territorial days received as much recognition as he, and fewer still displayed his flair for excitement.

Goodfellow also published articles on rattlesnake and Gila monster bites. There were rumors at the time that the bite of a Gila monster was fatal, but he disproved that theory in 1891 when he provoked one to bite him on the finger. He was sick for a few days but made a full recovery.

In Northern Sonora, he was known as "El Doctor Santo," the blessed doctor, following his heroic efforts to aid the locals following the great earthquake of 1887.

Whether he was called to a lonely outlaw hideout to treat some cattle rustler or summoned to the home of a poor Mexican family, Doc Goodfellow always responded. He could even drive a steam locomotive as well as any engineer or crawl down into a smoke-filled mine shaft to rescue trapped miners.

As mentioned earlier, in May 1881, Doc treated the notorious Curly Bill Brocius over in Galeyville after Lincoln County War veteran Jim Wallace shot him in the cheek and neck.

Following the famous gunfight behind the O.K. Corral on October 26, 1881, Goodfellow performed autopsies on the McLaury brothers and Billy Clanton. As Clanton was mortally wounded, he asked that his boots be removed because he didn't want to "die with his boots on." Doc was there and kindly obliged the youngster.

He also tended to the wounds of Virgil and Morgan Earp after the gunfight. He treated Virgil Earp's crippling wound by assassins in late December 1881 and Morgan Earp on March 18 following his shooting by members of the "Cow-boys," a loose-knit gang of outlaws.

On the evening of December 8, 1883, five desperadoes—Omer "Red" Sample, James "Tex" Howard, Dan Dowd, Bill Delaney and Dan Kelly—held up the Goldwater-Casteneda store, which also served as the local bank in Bisbee. Their take in the heist was small, about $800 and two gold watches.

As the bandits left the store and stepped out on the street, gunfire erupted. In just a few moments, three men, including a deputy sheriff, and a woman, eight months pregnant, lay dead or dying in the street. It became known as the "Bisbee Massacre."

The bandits were quickly captured and sentenced to hang on March 29, 1884. John Heath, who wasn't present at the massacre but was accused of orchestrating the robbery, demanded a separate trial and was sentenced to a term at the Territorial Prison in Yuma.

The citizens were outraged that Heath didn't get the death sentence, and on February 22, an angry mob stormed the jail, ignoring his condemned comrades, grabbed Heath and strung him up on the crossarm of a telegraph pole on Toughnut Street.

Doc was the county coroner and had been present at the lynching, as were many of the other citizens of Bisbee and Tombstone. His report states that Heath died from "emphysema of the lungs which might have been caused by strangulation, self-inflicted or otherwise, as in accordance with the medical evidence."

It would be Tombstone's only lynching.

During waking hours, the doctor could usually be found in one of two places, his office or downstairs in the saloon promoting a wager or sporting event. In 1872, he'd attended the U.S. Naval Academy briefly and was a boxing champion before being dismissed after a fight and hazing incident with a fellow midshipman. That was when he decided to go to medical school.

In a city full of colorful characters, Doc Goodfellow ranked with the best of them. Among his other talents, the pugnacious doctor was a hard drinker and a regular Casanova with the ladies of the town.

Doc's sense of humor, sporting character and frequent imbibing at the Crystal Palace in no way detracted from his research and practice as a medical physician.

He practiced in Tombstone for eleven years before moving to Tucson following the death of his good friend Dr. John Handy.

In 1898, when the Spanish-American War began, he joined General William Shafter's staff as a civilian volunteer and went to Cuba. His fluency in the Spanish language made him a valuable asset to the general. It was Doc Goodfellow, along with a bottle of Ol' John Barleycorn that he kept in his medicine bag, who helped negotiate the Spanish surrender. Following the capitulation, Spanish general José Toral gave the doctor, and one assumes the whiskey, credit for talking him into it.

There's no getting around it; Doc Goodfellow lived a full life, very different from that of an ordinary physician on the frontier.

9

ARIZONA'S FORREST GUMP

Jack Swilling is a name that goes almost unrecognized by Arizonans today. Much of what is known about him comes from tall tales, lies and half-truths. Jack himself could color a story redder than a Navajo blanket. In that he was no different from countless other yarn spinners on the American frontier who created the art of verbal hoaxing better-known as both *yarn spinning* and the *tall tale*.

A tall, powerful man, he was brave, generous to a fault, a wonderful family man and, for the most part, respected by his contemporaries. Swilling was the stuff of legends, and he truly was a product of his time.

The ubiquitous adventurer could be referred to as the "Forrest Gump" of territorial Arizona. He left his footprints on just about every important event that occurred in pristine Arizona during the 1860s. He participated in three of the most famous gold discoveries in Arizona history and was a Confederate officer in Arizona during the Civil War. Along with being the father of modern irrigation in the Salt River Valley, he was a founding father of Wickenburg, Prescott and Phoenix. Some historians even credit him with naming the future state capital. Then why is he barely remembered today?

Swilling was born on April 1, 1830, in South Carolina. His family moved to Georgia when he was fourteen. In June 1847, he joined a regiment bound for the Mexican War, and his unit fought in several battles. After the war, he returned to Georgia and later moved to Alabama, where he met and married a sixteen-year-old girl named Mary Jane Gray.

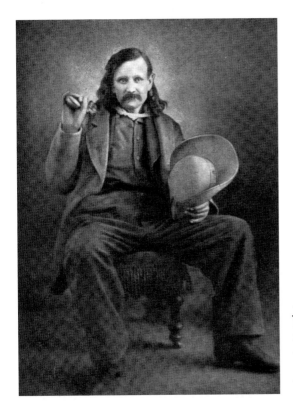

Jack Swilling had a knack for being in the right place at the right time in the cavalcade of Arizona's rich history from the 1850s to the 1870s. *Courtesy of Arizona, Prehistoric, Aboriginal, Pioneer, Modern, 1916.*

In 1854, a year after the birth of his daughter, Jack's skull was fractured from a blow from a large pistol. A bullet wound from a previous injury was also causing him severe pain. Morphine was prescribed to ease the pain, but it also brought an addiction. He began combining whiskey and opiates with the drug, and thus began his path to eventual self-destruction and an early death.

Jack and his wife split up for reasons unknown in 1856, and he headed west. He would never see her or his daughter again.

Jack's whereabouts for the next two years are uncertain, but he showed up again in 1858, working as a teamster on the Leech Wagon Road from El Paso to Yuma. It was during this time that he saw Arizona for the first time. By August of that year, he was in California searching for gold.

Colonel Jake Snively's 1858 gold strike on the Gila River a few miles east of Yuma eventually drew Jack to the new boomtown of Gila City. Constant raids by Tonto Apache on the prospectors led to the forming of a militia called the Gila Rangers. The men elected Jack as their leader, and on January 7, 1860, while leading a punitive expedition against the Apache, Jack and

63

his rangers came upon the Hassayampa River, previously unknown to white men. The area was too remote and dangerous to explore for gold, but Jack would return at a later date.

New gold discoveries in the Pinos Altos area in today's western New Mexico drew Jack to the area in 1861. The prospectors were being raided constantly by Apache bands under the leadership of the wily Mangas Colorados. A militia calling itself the Arizona Guards was raised, and Jack was elected first lieutenant. Over the next few months, he led them on punitive expeditions against the raiders.

The firing on Fort Sumter in the spring of 1861 would bring a brand-new adventure to Jack's storied life. For a brief time in early 1862, Confederate troops occupied what would soon become the territory of Arizona. This was part of a grand Confederate plan to occupy New Mexico and open a path to California that would make the South an ocean-to-ocean power.

The so-called westernmost battle of the Civil War was fought on April 16, 1862, when Union cavalry traveling east from California clashed with a small force of Confederate soldiers at Picacho Peak on the Gila Trail some forty-five miles northwest of Tucson.

This rugged 3,374-foot peak, a tilted remnant of ancient lava flows, also was a stage station for the storied Butterfield-Overland Stage Line and marked the halfway point between Tucson and the Gila River. The peak had long served as a landmark for Indians, Spanish explorers, mountain men, immigrants and American soldiers traveling along the Gila Trail. Springs located on the slopes of the mountain made it an important stop for thirsty travelers.

The Confederate occupation of Arizona began a few weeks earlier when Captain Sherod Hunter and his Arizona Rangers, numbering some fifty to one hundred men rode into Tucson on February 28, 1862, and raised the Stars and Bars. Two weeks earlier, on February 14, the Confederate Territory of Arizona had been officially created.

The citizens of Tucson welcomed the Texans, as they were all too happy to have a military presence after being constantly harassed by bands of Apache warriors. However, the Rebs were more interested in confiscating Union property than fighting Indians. Most of the whites in Tucson were Southerners and had little trouble obeying Hunter's demands they swear allegiance to the Confederacy.

One of Tucson's leading citizens, Esteban Ochoa, refused to swear allegiance. Ochoa had been running a successful freighting company in Tucson for several years, and he politely informed Captain Hunter that he

owed all his success to the United States and could not, in good conscience, swear allegiance to another government.

Captain Hunter respected Ochoa's decision and his honesty, but the businessman would have to leave. He was given a horse and gun, but his property was seized. Turned loose in the heart of Apache country, Ochoa rode east and eventually reached the Rio Grande Valley safely.

A few weeks later, after the Union forces had reoccupied Tucson, Ochoa triumphantly returned. A man of high character, he rebuilt his business with partner P.K. Tully. The freighting firm Tully and Ochoa was legendary during territorial days in the history of the Southwest. Ochoa remained a leading citizen in Tucson for years to come, serving as mayor and territorial legislator. He was instrumental in the early development of the public school system in the Old Pueblo.

The Arizona Rangers and Lieutenant Jack Swilling were originally organized in the Pinos Altos area in today's western New Mexico as the Arizona Guard to fight the raiding Apache but mustered into the Confederate army after Colonel John Baylor and his three-hundred-man Texas Brigade advanced into New Mexico in July 1861. On February 14, 1862, the Confederate Territory of Arizona was created. The new territory incorporated the southern part of New Mexico, including the villages of Mesilla and Tucson west to the Colorado River.

On March 3, 1862, Lieutenant Swilling led Hunter and his Arizona Rangers north from Tucson to the Pima Indian villages on the Gila River at Sacaton. Swilling had first come to the area in 1858, working as a teamster on the wagon road from El Paso to Yuma, and was familiar with the lay of the land.

Hunter launched a brilliant guerrilla-style hit-and-run campaign capturing and destroying food, supplies and hay that was being stored for Union general James Carleton's 2,300-man California Column. So effective were Hunter's raids the Union spies estimated he had a force of 800 men.

On March 10, Hunter cleverly lured a small Union force led by Captain William McCleave into a trap and captured eleven Yanks at Ami White's flour mill at Sacaton. Hunter and his men had arrived earlier, taking White prisoner; then Hunter posed as the mill owner until he got the drop on the unsuspecting McCleave. Furious at being duped, the feisty Irishman offered to fistfight the entire Rebel force to regain his freedom. The Rebs had to admire his spunk but saw no reason to take him up on the challenge.

Twenty days after the capture of McCleave and his men at Sacaton, there was a skirmish farther down the Gila about twelve miles east of the old Stanwix Stage Station where one Union soldier was wounded.

Afterward, Hunter and his Rangers returned to Tucson. He left Sergeant Henry Holmes and nine soldiers to set up a camp near the old Butterfield Stage Station in Picacho Pass as pickets.

The storied old mountain man Paulino Weaver, serving as a Union scout, warned the Yanks that Confederates were camped in the pass.

Meanwhile, the Union army continued to lumber its way up the Gila Trail toward Tucson, and on April 16, 1862, an advance unit led by twenty-six-year-old Irish-born Lieutenant James Barrett and a dozen men along with their scout, John Jones, rode into the pass, catching the Rebs by surprise and capturing three, including Sergeant Holmes.

Seven more Rebs were holed up in the thick brush nearby, and Jones advised Barrett to dismount, go into the brush on foot and root them out, but Barrett ignored the advice and rode in. A volley of furious gunfire greeted them. The Rebels who'd taken a defensive position in the brush opened fire, killing Barrett and two enlisted men and wounding three more.

During the Battle at Picacho Peak, fourteen Yanks and ten Rebels were engaged. This battle was not on the scale of Shiloh, Sharpsburg or Gettysburg, but to combatants, a firefight is a firefight.

The number of Confederate troops killed or wounded, if any, is unknown. Captain Hunter didn't mention any casualties when he filed his report, and there is no report from a reliable source the Confederates lost any men.

In 1892, the graves of Union privates George Johnson and Bill Leonard were located, and they were reburied at the Presidio in San Francisco. Lieutenant Barrett's grave was never found.

Neither Hunter nor Lieutenant Jim Tevis, who rode up to Picacho after the fight to get details, reported any killed or wounded. Both were always honest in their reports and didn't try to hide anything, so it's likely no one was wounded or killed. They reported the three men taken prisoner and that's all.

There was no surviving muster roll, and the names of only sixty-seven of Hunter's Rangers are known. About half were Texans and the rest from New Mexico.

John Jones was sent into Tucson to gather information. Hunter was suspicious of the spy, but after making him swear allegiance to the Confederacy, he was released. Jones was ordered to not head back up the Gila Trail, so to avoid detection, he headed south toward Mexico, cut across the Camino Del Diablo and returned to Yuma, where he provided the Union command with information regarding the small size of the Confederates force. California newspapers had been claiming there were thousands of Rebels in Tucson preparing to invade their state.

The California Union force was advancing so slowly across the desert old Paulino Weaver got fed up and quit at Sacaton, saying, "If you fellers can't find the road to Tucson from here you can all go to hell."

Following the incident at Ami White's mill at Sacaton, Lieutenant Swilling was picked to escort Captain McCleave and the rest of the Union prisoners of war to New Mexico. On the journey, he and McCleave spent many an evening around the campfire becoming friends, and it is likely Jack talked about the possibility of finding gold in the rugged central mountains north of the Gila River that he'd previously explored.

When the group reached New Mexico, Swilling learned that General Sibley's Confederate army had been defeated at Glorieta Pass east of Santa Fe and was in full retreat down the Rio Grande back to Texas. The Confederate dream of capturing the West was over. By this time, Jack had already decided to desert the Confederate army.

"I don't want the blood of white men on my hands," he told Captain McCleave, saying he'd joined the Arizona Guards to fight the Apache, not his fellow white men. He resented the treatment of the New Mexican citizens by the Confederates, who had looted and plundered their way up the Rio Grande. He released McCleave and the others and headed back to Pinos Altos. His days as a Confederate officer were now behind him.

Jack Swilling, erstwhile Confederate officer, hired out for the Union as a civilian express rider and later as a guide and scout during army campaigns against the Apache in the Pinos Altos country.

The fateful meeting in 1862 between him and the legendary explorer Joe Walker was probably a coincidence, but the effects were far-reaching. Jack and the soldiers in the area were attempting to capture the wily old chief Mangas Colorados. Mangas had been seriously wounded a few months earlier against Carleton's men at the Battle of Apache Pass and was ailing, but even in poor health, he was a formidable warrior capable of terrorizing the miners and prospectors in the area.

Walker and his party were on their way to explore Arizona's rugged central mountains but had little knowledge of the area, and Swilling knew the country better than any other white man. When the two met at the ruins of Fort McLane, New Mexico, a plan was hatched to capture the wily old chief and thus allow the Walker party safe passage through the mountains that straddle today's Arizona–New Mexico border. Walker had spent most of his life in the West as a fur trapper and explorer and was probably more Indian than white man. He'd married a Shoshoni woman and raised a family among her people for fifteen years. She died during the winter of

1846–47. Walker wasn't interested in killing Mangas, he just wanted to take his party of prospectors through the old chief's domain and search for gold in Arizona.

Guided by Swilling, the would-be prospectors headed west from Pinos Altos but found their path blocked by Mangas and his warriors. For a time, the two old gray-headed warriors sparred like grand chess masters mapping out their strategies. During the stalemate, Swilling went out to parley with the chief and managed to get the drop on him. Mangas was captured, but the officer in charge of the area, Lieutenant Colonel Joseph West, ordered Walker to turn the chief over to the soldiers, who proceeded to torment and execute him shortly thereafter. It was not one of the prouder moments in the history of the Frontier Army.

Meanwhile, members the Walker Party, running short on supplies, turned south to the Gila Trail and headed for Tucson, where they hoped to re-equip. Many of Tucson's citizens had evacuated to Sonora or California to escape the wrath of the Apache, and they were unable to supply the prospectors, so Swilling led them north to the Pima Indian villages at Sacaton, where they were able to purchase supplies. The party traveled north into the Salt River Valley and up the Hassayampa River to the headwaters in the Bradshaw Mountains, where in May 1863 they found a bonanza in gold along the creeks where Prescott is located today.

Arizona had become a U.S. territory on February 24, 1863, and later that year, when the gubernatorial party arrived in Santa Fe on its way to establish a capital city, General Carleton advised the men to locate it in the mountains of central Arizona near the gold strike rather than the logical choice, Tucson.

Once again, Jack Swilling played an important role in territorial history with the establishment of the new capital at Prescott.

A few weeks later, Jack was returning from a trip to Tucson when he joined another party of gold seekers led by the scout Paulino Weaver. He was with Weaver when they made the richest single placer gold strike in Arizona at Rich Hill, north of today's Wickenburg. Carleton sent New Mexico surveyor general John Clark to investigate the strike, and on August 29, 1863, he walked to the top of Rich Hill and later wrote: "[W]here Jack Swilling's placer is situated...Saw a quantity of the gold which had been picked up....The placer has already yielded over 20,000 dollars & not half of the ground has yet been worked over."

Jack sent two sizable nuggets to General Carleton, who in turn sent the largest one to President Abraham Lincoln.

Allegedly, Jack carried a five-ounce nugget around that he would hock when short on cash then retrieve when times were better.

Always on the move, Jack was in Tucson in the spring of 1864, where he met the love of his life, Trinidad Escalante, a pretty, fair-haired, blue-eyed seventeen-year-old. After a brief courtship, they were married on April 11, 1864.

Soon after their marriage, Jack and Trinidad returned to Yavapai County. They farmed at Walnut Grove on the Hassayampa for a while before moving down the river to Wickenburg, where he continued to farm and engage in various prospecting adventures, one of which would have a great impact on the history of Arizona.

In 1867, when Jack arrived in the Salt River Valley, the only resident was John Y.T. Smith, who was running a hay farm near today's Sky Harbor International Airport. Swilling noted the ruins of a vast irrigation system of ditches and canals left over from the prehistoric Hohokam Indians, who had abandoned the area several hundred years earlier.

Swilling was quick to note the agricultural potential in the valley. Located nearby were a number of mining towns in the Bradshaw Mountains along with the army posts Whipple, Verde and McDowell.

In early December 1867, after having raised $10,000 and recruiting sixteen men from Wickenburg, the Swilling Party headed for the Salt River Valley and began cleaning out the old canals and ditches and digging new ones.

By the spring of 1868, crops were being irrigated from the "Swilling ditch," and the population had reached fifty.

The first federal census in 1870 counted 164 men and 61 women. The youngest was twenty, and the oldest was thirty. There wasn't a doctor, lawyer, banker or teacher in the whole settlement. In October 1870, they selected a townsite and chose to call the new town Phoenix for the mythical bird that each millennium flies into its own funeral pyre before emerging from the flame reborn.

Jack filed a 160-acre claim under the Homestead Act at what is now the southeast corner of Thirty-Second Street and Van Buren. In the center of the farm, he built a nine-room adobe house for his family.

By all accounts, Jack was a loyal husband to Trinidad and a doting parent to their nine children. The nearly five-thousand-square-foot adobe home he built for them was for a time the largest in Phoenix. He was respected by most of his contemporaries. One described him as "lithe and graceful as a panther, with long black hair floating down his back…robed in buckskin and looking like the frontispiece of a dime novel."

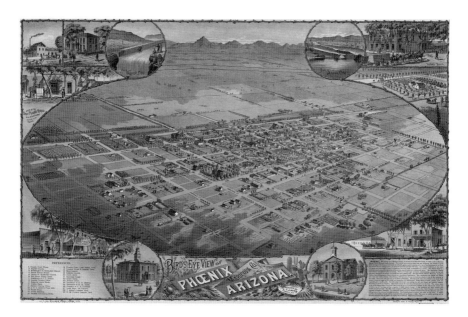

Dyer's "Bird's-Eye View of Phoenix 1880." *Courtesy of Arizona Historical Foundation.*

Swilling's Castle became the community meeting place, and in June 1868, he was elected justice of the peace for the Phoenix Precinct. He was named postmaster and engaged in several other business ventures, including digging more irrigation ditches in the valley.

Jack had hoped his home would be the center of the new city, but to his great disappointment, the citizens voted to locate it some four miles farther west at today's Van Buren and Central Avenue.

Soon Jack tired of life in Phoenix, packed up his family, moved north and began farming along the Agua Fria River at today's Black Canyon City. He also became the unofficial first station keeper for the Phoenix-to-Prescott stagecoach line. He was a gracious host, and his home was always open for weary travelers. He loved prospecting, and much of his time was spent searching for gold and silver in the Bradshaw Mountains.

In 1858, the death of his friend Colonel Jake Snively, an officer in the Texas army during the 1836 revolution and the man who made Arizona's first gold discovery, at Gila City, deeply affected Jack. The two had been friends and neighbors in Phoenix. On March 27, 1871, Snively and four others were hunting for gold in the Hieroglyphic Mountains when they came under attack by a large party of Tonto Apache at White Picacho. According to a newspaper account, Snively was wounded and "was left to

the mercy of the savages by his comrades, who became panic stricken, and ran away."

Another group went out to retrieve his remains, but the body was badly decomposed, so they buried him on the site. For the next several years, Jack brooded over the fact his friend hadn't got a proper burial. He and a couple of friends found Snively's remains and reburied them near his home on the Agua Fria.

On April 19, 1878, a stagecoach was robbed by three bandits near Wickenburg. Witnesses claimed one of the outlaws looked like Jack. Swilling was taken to the Yuma jail to await trial. He'd made a number of enemies over the years, and it seems they wanted to see him locked up regardless of his innocence or guilt. Jack was in poor health, and while lying in jail awaiting a trial, he contracted pneumonia and died on August 12, 1878. The exact whereabouts of his grave remain a mystery.

Not long after Swilling died, authorities arrested John Rhodes and found him guilty of the stage robbery. Warrants were sworn out for the other two culprits, Lewis Rondepoach and John Mullins. Since mail robbery is a federal offense, territorial records have no information on their fate.

Jack's wife, Trinidad, tried to collect on his $5,000 claim against the federal government for Indian depredations, but as far as anybody knows, all she got was the standard reply from Washington bureaucracy, "The check's in the mail."

HI JOLLY AND THE CAMEL CORPS

One of the West's most bizarre events took place along the Colorado River on a gray January morning in 1858. A camel caravan looking like something right out of the Arabian Nights was preparing to cross the muddy river.

A group of camels plodding across the desert was indeed a peculiar sight. Their strange mannerisms and homely looks were a great curiosity to the local natives but prompted mules and horses to stampede.

This unfamiliar event was followed by something just as outlandish in the Mojave Desert. A tiny boat belching steam was churning its way downstream, its noisy, wood burning engine hurling billowing clouds of black smoke skyward. The steamboat, the *General Jesup*, and skipper George Johnson were returning to Yuma after exploring the Colorado River to learn more about the navigability upstream to Black Canyon. The camels were returning to New Mexico from California following their successful survey of the thirty-fifth parallel for a wagon road between Albuquerque and Los Angeles.

Although this chance meeting in the middle of nowhere was accidental, both were part of a grand plan by the U.S. government to establish passageways through and across the vast terra incognita that was now a part of the United States. Both are relatively unknown chapters in the illustrious history of the West.

The United States had just acquired 529,000 square miles of virtually unexplored and unmapped land as a result of the recent war with Mexico—all or parts of today's Arizona, California, Nevada, Utah, New Mexico, Wyoming and Colorado.

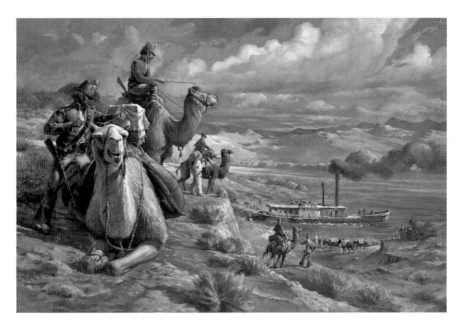

Edward F. Beale and the Great Camel Experiment, by Bill Ahrendt. *Courtesy of Bill Ahrendt.*

About that same time, gold was discovered in California, and thousands of immigrants were heading west. They were going to need roads to get there. The storied Army Corps of Topographical Engineers was charged with surveying these transcontinental roads from the Canadian border to the Mexican line. This elite group of soldier-scientists, established in 1838 and handpicked from the top graduates of West Point, was a separate unit for only twenty-three years, but during that short time it gained more knowledge of the terra incognita than in the previous three hundred years. And they probably did more, in proportion to their small numbers, toward the "winning of the West" than any other group in American history. In those days before specialization, these young engineers were required to have a working knowledge of botany, biology, ethnology, geology, ornithology, anthropology and meteorology. Since cameras weren't available, they were trained as sketch artists to record both the animate and inanimate. These unsung heroes who mapped the roads west were the prototypes for the seven Apollo astronauts of the 1960s who set out to explore another new frontier. Future transcontinental railroads would follow these same surveys. And a century later came interstate highways.

Before the coming of the railroads, the task of transporting goods across the great southwestern deserts was never an easy one. The terrain was rough

enough to tear up the feet of horses and mules. Water was always scarce, and lack of suitable forage for the animals made it necessary to carry the feed on pack animals, taking up valuable space. A beast of burden was needed that could pack a heavy load, live off the natural resources along the way and travel a long distance without a drink of water.

Secretary of War Jefferson Davis wanted to test the feasibility of using camels as beasts of burden across the waterless land. The Great Camel Experiment would be unique in the annals of western exploration.

During the Seminole Wars of the 1830s, Second Lieutenant George Crossman first came up with the idea of using camels. He pitched the idea to Major Henry Wayne, who in turn pitched to Mississippi senator Jefferson Davis. When Davis became secretary of war in 1853–57, he pitched it to President Franklin Pierce for an appropriation. After Congress appropriated $30,000, Major Wayne, accompanied by U.S. Navy lieutenant David Porter, set out on the USS *Supply* to the Middle East to purchase some camels.

On February 15, 1856, the ship embarked for America with thirty-three camels on board. On the way, one died and two were born, so they arrived on May 14 with a net gain of one camel. A year later, another shipload arrived, increasing the total by forty-one.

The man chosen to lead the survey of the thirty-fifth parallel was the irrepressible Lieutenant Edward Fitzgerald "Ned" Beale. Beale, a graduate of the Naval Academy, is undoubtedly one of the unsung heroes of the American West. His life story reads like something out of a dime novel. In December 1846, he was with General Stephen Watts Kearny's Army of the West when it was pinned down and under siege at San Pasquel, near San Diego, during the Conquest of California. Beale, Kit Carson and a Delaware Indian scout sneaked through enemy lines and traveled on foot to San Diego for reinforcements to rescue the trapped American force. Following the discovery of gold in California, Beale was chosen to carry the news to President Millard Fillmore. Disguised as a Mexican, he made an epic dash through Mexico, outriding his pursuers and shooting his way out of several scrapes. He delivered a pouch of gold nuggets to the White House, proving the gold discovery was not a hoax and triggering the California Gold Rush.

The arrival of camels in the American Southwest failed to bring a chorus of cheers from the packers and muleskinners. They should have been welcomed, as they could carry more than seven hundred pounds of baggage, live off the local forage and go for long periods without water. They could travel anywhere from thirty-five to seventy-five miles in a day. Alas, the homely beasts were extremely stubborn, had terrible breath and were

Lieutenant Edward Fitzgerald Beale, camel driver, war hero and engineer. He's dressed in the disguise he used crossing Mexico in 1848 to carry the news of the discovery of gold in California to Washington. *Courtesy of Scottsdale Community College.*

known to be extremely temperamental. Couple that with a spirit of intractable independence, and they were difficult to manage. The muleskinners hated them; packers and teamsters cursed them unmercifully. The language barrier presented no small problem. The Americans couldn't speak Arabic, and the camels wouldn't learn English.

Following the old adage "it takes a camel driver to drive a camel," the government had the foresight to import camel drivers. They were a colorful bunch with names like Long Tom, Short Tom and Greek George. These weren't their given names but had to do, as the Americans couldn't pronounce their Arabic names anyway. The most famous of these was Hadji Ali, and since that one didn't roll off the tongue, his name was corrupted to Hi Jolly.

His original name was Philip Tedro, and he was born in Greece around 1828, of Greek and Syrian parentage. At the age of twenty-five, he converted to Islam and took the name Hadji Ali. Later in life, he reverted back to his given name.

By the middle of August 1857, the camel brigade was on its way. Accompanied by the Middle Eastern "camel conductors" in their traditional garb, the caravan made a colorful spectacle as it passed through villages along the way. Lieutenant Beale looked and played the part of a circus ringmaster riding in a wagon painted bright red. The camels were packing seven hundred pounds, twice what the mules could carry. Beale usually rode a mule, but for a social call on a military post, he climbed on a white camel named Seid. No doubt the appearance of a military officer sitting high on a white camel had the desired effect.

Beale couldn't have been more pleased with his camels. They endured the arid lands between Albuquerque and the Colorado River especially well. During a stretch of thirty-six hours without water the horses and mules suffered, but the camels didn't falter. On the contrary, the camels gazed at the frenzied animals with contempt.

The powerful mule lobbyists in Missouri and Washington were the most vocal opponents of the camel experiment. They threw a hissy fit. In reality, they didn't like the competition. However, Lieutenant Ned Beale, the officer who implemented the camel survey, championed their attributes, calling them "lovable and docile."

When the camels were assigned to Beale, he had been adamantly opposed to them, but the more he came to know them, their endurance and ability to cover great distances, the more he became their biggest supporter. Still, he had a hard time convincing others, especially when whole pack trains were known to stampede at the mere sight of the camels.

The beasts passed the supreme test when Beale was challenged to pit his camels against packers' mules on a sixty-mile endurance race. Using six camels against twelve mules, a two-and-a-half-ton load was divided among the camels and two army wagons, each drawn by six mules. The camels finished the race in two and a half days, while the mules took four.

On October 17, 1857, the camels arrived at the Colorado River near Needles. At first, the camels eyed the river with suspicion, so the teamsters urged some horses and mules to cross in order to encourage the camels to follow. When the heavy current swept the animals away, the camels became even more contentious. Hi Jolly selected the strongest camel in the herd to swim the river, and after he swam across with ease, the others followed suit. With Hi Jolly singing to encourage his camels to swim the swift current of the river, they successfully crossed with no losses. Two horses and ten mules were lost on the crossing. The bodies of the horses and mules were gathered in by the local Indians, who butchered and then held a feast.

The camel caravan reached Fort Tejon, California, in November still carrying their loads of six hundred to eight hundred pounds. Their historic mission was accomplished.

The outbreak of the Civil War in 1861 ended any hope for the building of a railroad along the thirty-fifth parallel in the near future. The government had no more use for its camels, and they were either sold as military surplus or turned loose to roam the western deserts of Arizona and California.

The army's experiment with camels was short-lived, but Hi Jolly remained in the Southwest. For the next forty years, he would divide his time between delivery of the U.S. mail, hauling freight (over roads he had helped to explore and establish), prospecting and serving the cavalry as a scout and mule packer.

He met Gertrudis Serna in Tucson, and they were married in 1880. The couple had two daughters, but Philip continued to drift and finally took up residence around Tyson's Well. Gertrudis and Philip remained estranged until his death in 1902 on the road between Wickenburg and the Colorado. He'd gone out looking for a stray camel. Later, some cowboys working cattle came upon his body, his arms wrapped around the neck of the young camel. Both had perished in a sandstorm. The name Philip means "lover of horses," but in reality, Philip Tedro was a camel whisperer.

In 1934, the last camel from the original group died at the age of eighty at a zoo in Los Angeles. The average life of a camel is fifty years, so the climate of the Arizona desert must have suited him. The last camel, a descendant of the original herd, was captured in the wilds of Arizona in 1946. The last reported sighting of a wild camel in North America was in Baja California in 1956.

When the rails did cross Arizona in 1883, they closely followed the survey Beale and his camels made nearly a quarter century earlier. In 1912, the wagon road became part of the National Trails Highway, also known as the Ocean-to-Ocean Highway from the Atlantic to the Pacific.

On November 11, 1926, federal highway officials put the finishing touches on the new 2,400-mile interstate between the Chicago and Los Angeles and named it Route 66. But that's a story for another time.

II

SHANGRI-LA ON THE BANKS OF
THE SANTA CRUZ RIVER

When one imagines pristine Arizona's dry, desolate, sunbaked deserts in the 1850s, it's difficult to picture any of it as being a utopian Shangri-La, but for a brief period, in a beautiful green valley at the foot of the majestic Santa Rita Mountains, there was just such a place.

In his twilight years, Charles Poston, recognized today as the "Father of Arizona," wrote glowingly of it: "We had no law but love and no occupation but labor, no government, no taxes, no public debt, no politics. It was a community in a perfect state of nature."

In August 1856, Poston, accompanied by a group of German miners and a brigade of rough-hewn Texas frontiersmen described as "not afraid of the devil…armed with Sharp's rifles, Colt revolvers and the recklessness of youth" arrived in the small pueblo of Tucson. They were on their way to occupy the abandoned settlement of Tubac farther up the Santa Cruz River and reopen some of the old mines from the Spanish colonial period in the area. He'd explored the mountains west of the river two years earlier and found rich deposits of silver.

The old Spanish presidio was abandoned and all the adobe buildings in disrepair. The first order of business was to get the old town up and running again. The three-story tower was restored and served as a lookout. The armory became a storehouse for supplies. Lumber for construction came from the nearby Santa Ritas.

The miners found gold in the streams and silver in the mountains. The richest silver mines were west of the river in the Cerro Colorados, where the

silver assayed out at $950 to the ton. One mine assayed at $7,000.

The following year, James "Santiago" Hubbell, a New Mexico trader, brought a wagon load of goods to Tubac and, on his return trip, hauled a load of rich silver that assayed at $1,500 to the ton back up the Santa Fe Trail to Kansas City, making Americans aware of Arizona's rich silver deposits.

Hubbell came to New Mexico shortly after the Mexican War ended. He married Jualianita Gutierrez from an old Castilian family. In 1853, their son John Lorenzo was born. As a young man, John lived among the Hopi and Navajo, where he learned to speak their languages. He came to the area in 1876 and, two years later, bought a trading post in northeastern Arizona that he named Mucho Ganado in honor of a Navajo chief.

Charles Poston arrived in Arizona in the 1850s. During the next decade, he lobbied in Washington to secure territorial status and is regarded today as the "Father of Arizona." *Wiki Commons (CC BY 2.0).*

Little has changed since the days of Don Lorenzo Hubbell. Today, the Hubbell Trading Post is a national historic site and still open for business, serving both the Navajo and tourists.

The mining camp bonanza gave a boost to commerce along the entire Santa Cruz River Valley. Skilled miners were paid fifteen to twenty-five dollars a month, a tidy sum for the times. By 1857, the population in the valley had grown to 3,500, and a military post was established at Calabasas, just north of today's Nogales. Pack trains from Mexico brought in food staples and French wine from Guaymas. Fruits and vegetables were purchased from the nearby mission at Tumacacori.

Since the Mexicans couldn't read English, Poston devised a cardboard currency called *boletas* to pay their wages. Renderings of animals were used to indicate the value. A pig was worth twelve and a half cents; a calf, twenty-five cents; a rooster, fifty cents; a horse, one dollar; a bull, five dollars; and a lion was worth ten dollars.

The revolutions in Mexico and the California Gold Rush had depleted the male population in northern Sonora. In some villages, the ratio of women to men was twelve to one. This caused a mass exodus of unattached young

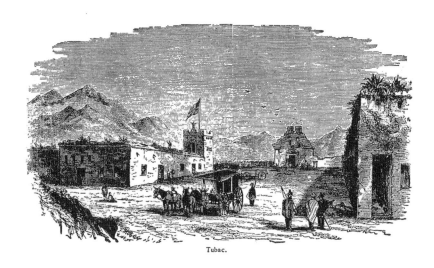

Tubac.

Tubac, Charles Poston's Shangri-La on the banks of the Santa Cruz River. *Courtesy of Scottsdale Community College.*

women, who proceeded to head for the boomtown of Tubac. It also became a Gretna Green for young runaway couples who couldn't afford the twenty-five-dollar fee the priest charged them to marry.

Poston was Tubac's *jefe*, and by Mexican law, that made him the magistrate or the mayor (*alcalde*). Poston referred to himself the "El Cadi." He married the young couples for free and even gave them a wedding present. He baptized their babies and, if necessary, granted them divorces.

Of the women, Poston wrote: "Sonora has always been famous for the beauty and gracefulness of its senoritas. They really had refining influence on the frontiersmen. Many of them had been educated at convents and they were all good Catholics....They could cook, sew, sing and dance."

The observant El Cadi also wrote, "They are exceeding dainty in their underclothing [and] wear the finest linen they can afford."

The ladies referred to the American men as *los goddamies* for their propensity to use the term with so much frequency, and the few American women were *las camisos colorados* due to their fondness for red petticoats.

They could give a good account of themselves in men's games of chance: "[T]hey were expert at cards and divested many a miner his week's wages over a game of monte."

Alas, it was too good to last. The archbishop in Santa Fe, Jean Baptiste Lamy, dispatched Father Joseph Machebeaf to Tubac to check things out.

Shocked at this "perfect state of nature," Machebeaf immediately declared all the marriages performed by Poston null and void. Naturally, there was much wailing and dismay in Tubac. Something had to be done to quell the unrest, so El Cadi and the padre worked out a deal: Poston would make a charitable donation of $700 to the church, the priest would re-marry the anxious couples and all transgressions would be forgiven.

Unfortunately, things got ugly in a hurry. In September 1857, a California adventurer named Henry Crabb led a group of some forty *filibusteros* (land pirates) from California into Caborca, Sonora, and tried to set up a little country of their own. The Mexicans retaliated and killed them all, then imposed an embargo, making it unsafe for Americans to cross the border.

Then, some Sonoran rancheros in pursuit of Apache raiders crossed the border and invited Poston and his men to join them in a punitive expedition to reclaim some three hundred horses and mules that had been stolen. They promised to divide the animals reclaimed equally.

Up to then, Poston had an agreement with the Apache to not interfere with their traditional raids from their strongholds in the mountains to the north through the Santa Cruz Valley into Mexico.

He refused their offer, so the Mexicans headed north to the small settlement at Canoa and made the same offer. These were newcomers from Maine who were cutting lumber up in the Santa Ritas and unaware of the arrangement. Unwittingly, they joined the Mexicans. They succeeded in routing the Apache and reclaiming the stolen livestock—but at a high cost. A few days later, the Apache swept down on Canoa, annihilated the settlers and destroyed the camp.

In late 1860, a youngster named Felix Tellez, the stepson of John Ward, was kidnapped by a band of Aravaipa Apache at Ward's ranch nearby Sonoita Creek. Cochise, living with his band in Apache Pass, was the usual suspect in any mischief in the area. In early 1861, a young army lieutenant named George Bascom led a force of soldiers from Fort Buchanan to Cochise's camp and falsely accused him of kidnapping the child. Cochise denied taking the lad, and when the soldiers attempted to take him hostage, the chief managed to escape. In the aftermath, several were killed on both sides, including some of Cochise's relatives.

Up to then, Cochise had been relatively friendly with the Americans, but he declared a take-no-prisoners war that lasted for ten years. The so-called Bascom Affair coincided with the outbreak of the Civil War. All the military posts in Arizona were abandoned, and the settlers were left to fend for themselves.

Felix Tellez grew up among the Apache, adopted their ways, married an Apache woman and took the name Mickey Free. He went on to become one of the great scouts for the U.S. Army during the Apache Wars.

Charles Poston's thriving little utopia was no more. The Apache moved in once again, destroying the town, looting and slaughtering both Mexicans and Americans. Mexican bandits killed and plundered innocent residents in the Santa Cruz Valley. The bandits killed Poston's brother John at Cerro Colorado.

Poston left Arizona in 1862, barely escaping with his own life, and headed for Washington to promote separate territorial status for the place folks were now calling Arizona. The Territory of Arizona, created from the western half of New Mexico, was established on February 24, 1863.

In 1899, the territorial legislature officially recognized Poston as the Father of Arizona and awarded him a small pension. He died three years later and was buried atop a lonely butte north of the town of Florence.

NIGHTLIFE IN THE TOWN
TOO TOUGH TO DIE

Mining towns like Tombstone created a lot of instant wealth for many in the community, and they were bent on showing they had just as much class and culture as New York and San Francisco. And they were willing to prove it by building nice theaters and paying top dollar to bring in well-known performers and entertainers. Still, some stock companies went broke, became stranded and had their property impounded. One such story is told about the time the town marshal held the performers' trunks until they paid their hotel bill. Unfortunately, this happened while they were on stage performing in tights.

For the next several days, the guys and dolls had to go around town in wearing tights. Finally, several citizens took pity and paid their hotel bill.

The most imposing and best known theater in Tombstone was Schieffelin Hall, inspired by the town founder. For two decades, it was the largest theater between El Paso and San Francisco. Construction on the tallest adobe building in the United States began in early 1881 and was completed by May. It stood two stories high, was 130 feet long with a 40-foot stage, could seat seven hundred patrons and presented legitimate theater.

There were also a number of lesser known theaters in town. On Allen Street was the Danner and Owens Hall, which had a large auditorium with chandeliers and theater boxes, curtains and footlights. On Sixth Street was an opera house that later became the Fontana Dance Hall. It was also called the Free and Easy. Dances and union meetings along with traveling theater troupes were held at Ritchies Hall on Fifth Street and the Turn-Verein Hall on Fourth and Fremont Streets.

Down on Allen Street was the Bird Cage, a theater more for the working class. It opened on December 23, 1881. It was built for only $600 by a colorful character and former performer named Billy Hutchinson.

At first, Billy and his wife, Lottie, wanted the Bird Cage to be an establishment that catered to families, but that didn't pan out, so the entertainment switched to lowbrow. The girls performed little singing and dancing skits for the audience of cowboys, cattle rustlers, smugglers and miners. They also worked the room as waitresses, hustling drinks and prostituting to supplement their incomes.

A reporter for the *Tucson Star* infiltrated the place in October 1882 and described the action:

> *A dizzy dame came along and seated herself alongside of me and playfully threw her arms around my neck and coaxingly desired me to "set 'em up."…Her bosom was so painfully close to my cheeks that I believed I had again returned to my infantile period…She and I, after drinking the liquid, parted at last—she in search of some other gullible "gummie."*

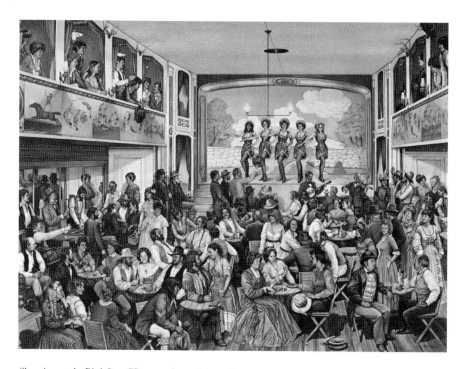

Showtime at the Bird Cage Theater, where the cowboys and miners enjoyed lowbrow performances. Artwork by Richard Axtell. *Courtesy of Scottsdale Community College.*

A crowd favorite at the Bird Cage was Pearl Ardine, an Irish jig dancer whose specialty was picking up money thrown to her and jamming it into her stockings without missing a step. There was also Alma Hayes, a.k.a. Mademoiselle De Granville, who was billed as "the woman with the iron jaw." This so-called female Hercules packed the room by performing feats of strength and specialized in picking up heavy objects with her teeth. Nola Forrest was a beautiful comedienne who won the heart of a bookkeeper—he was arrested for embezzling nearly $1,000 from his employer in order to buy jewelry for his dream girl.

Another popular act was the "Human Fly"—women dressed in tights and skimpy costumes crept along the ceiling upside down. After supporting clamps failed and one of the performers fell to her death, the act was canceled.

The popular *Uncle Tom's Cabin* played there in June 1882. Chaos occurred when little Eliza was being pursued by Simon Legree and his bloodhound while crossing the icy river. An inebriated cowboy, caught up in the drama, pulled his pistol and plugged the dog. The audience was outraged and pounced on the clueless cowboy, who was finally rescued by a peace officer and hauled off to jail. The next day, the cowboy, now sober and repentant, offered his horse to the troupe as recompense for the dog.

Owner Billy Hutchinson was the personification of that old saw "Once a performer always a entertainer." One night, a drunken member in the audience kept hurling catcalls and insults at the performers. Billy walked out on the stage and asked the man to silence himself. This only provoked more catcalls. Billy then sent two bouncers up to the box. There came the sound of a scuffle, shouting, arguing and then a gunshot. The horrified customers then witnessed a body fall from the box and onto the stage. The body turned out to be a straw dummy that resembled a scarecrow. Billy was having a little fun with his audience.

Pat Holland, newly elected Tombstone coroner, was standing backstage at the Bird Cage one evening as a sharpshooter was preparing to shoot an apple off the head of a young lady. Annoyed the shooter was taking too long to line up his shot, Pat grabbed an old prop musket backstage and, thinking it was loaded with nothing but powder and wadding, blazed away. The shot not only blew the apple to pieces but also took off a large chunk of the gal's topknot and sent it smashing into the opposite wall of the theater. It turned out one of the employees had taken the musket out rabbit hunting that afternoon and left it loaded.

When the Hayne Operatic Company out of San Francisco arrived in Tombstone in December 1879 to perform Gilbert and Sullivan's *H.M.S. Pinafore*, one of the actresses, using the stage name May Bell, played the role of Cousin Hebe. May Bell apparently caught the eye of two of the most prominent characters in a drama of their own that would play out a few years later. May Bell's real name was Sadie Marcus, and the two gentlemen were Wyatt Earp and Johnny Behan. She would live with the latter briefly before having a longer relationship with the former.

One night in the Bird Cage, Buckskin Frank Leslie and Uncle Dave Adams were in their cups, sitting in a box seat and taking in the show when a fella sitting in an adjacent box draped his leg over the rail. Frank and Uncle Dave yelled at him to remove the offensive leg. Either he didn't hear them or chose to ignore the two. Frank yelled again, "Take in your leg!" The leg continued dangling over the rail, so Buckskin Frank drew his six-shooter, took aim and shot the heel off the man's boot. The leg quickly disappeared back into the box, proving once again that old adage "You'll get more with a kind word and a gun than with just a kind word."

Hutchinson sold the Bird Cage in 1883, and in January 1886, Joe Bignon and his lovely wife, Minnie, took possession. Standing six feet tall and weighing 230 pounds, she was better known as Big Minnie. Joe was short, something that made Minnie look even taller. She cut quite a figure strolling around town in her pink tights. Despite her extra-large size, Minnie was a ballet dancer. She had a good heart and a simple, childlike soul and was a favorite in Tombstone. She and Joe did stage shows, and the crowds loved them.

Minnie could also handle troublemakers. One night, a drunk put a nickel on the bar and demanded a drink. When the bartender refused, the rowdy pulled his pistol and threatened to shoot up the place. "I'll handle this," Minnie said as she walked up to the rowdy, picked him up, carried him to the door and threw him halfway across Allen Street.

The boomtowns of the Old West had a shortage of eligible young women, and that void for the lusty young men was filled by what were euphemistically referred to as good-time girls, shady ladies, soiled doves and ladies of the evening. An alternative was provided by a census report that referred to one as a "ceiling expert," while another described herself as being "horizontally employed."

Tombstone's working girls included a colorful group: Little Gertie the Gold Dollar, Dutch Annie, Lizzette the Flying Nymph, Blonde Marie, Madame Mustache and Crazy Horse Lil. These charming specimens of Eve's flesh

were not only tolerated but welcomed in Tombstone, where the fine art of minding one's business was highly developed.

These hostesses who worked in the bars were there to meet, entertain and satisfy the lusty needs of the customers. Mainly it was to get them to buy drinks, for which the girl's commission was normally two and a half cents per drink. Sometimes they received 20 percent of what a man spent on liquor. Most supplemented their income by prostitution. They resided in cheap shacks clustered behind the saloons where they plied their trade. There was no medical inspection available, and venereal disease was rampant. Thanks to the cheap liquor they drank, drugs they consumed, disease, poor living conditions and the hard lives they lived, these unfortunate ladies died by the score. The lucky ones quit the trade before the drugs, disease and alcohol did them in.

Big Minnie Bignon, actress, singer and ballet dancer. She was over six feet tall and weighed 230 pounds. Occasionally, she also was the bouncer at the Bird Cage. *Courtesy of Scottsdale Community College.*

Some madams were honest and good businesswomen. Most notable was Cora Adams. She was about thirty-five, pretty, with good manners and bearing. What set her house apart was the strict rule on honesty when it came to money. When a gentleman became noticeably drunk, his valuables were taken from him, and two invoices were made, one for him and one for Adams. When he called it a night and got ready to leave, his valuables were returned.

Residents of Tombstone bragged with civic pride that their prostitutes were superior in charity, decorum, honesty and manners to those in towns like Bisbee, Charleston and Tucson.

The upper-class gentlemen of Tombstone frequented the house of a beautiful French madam named Blonde Marie. She had no bar in her establishment, and drinks weren't served, so fights were rare. She did provide a bottle for her trusted clients. Marie worked for a French-run syndicate operating out of San Francisco. Occasionally, she traveled to Paris and always returned a few weeks later with what the locals referred to as "fresh meat," a new crop of young French girls. Marie accumulated a fortune from

her successful business, and by the mid-1890s, she had returned to Paris for good, presumably to reside in elegant splendor.

Crazy Horse Lil was cut of a different cloth. She was mean and tough. She loved to fight, and her brawling kept her in jail about a third of the time. Her boyfriend was an aptly named Irishman named Con O'Shea. During a party one night with some of the high-class citizens (without their wives), three men came in and robbed her place, taking hundreds of dollars in cash from the partiers. Lil complained loudest of all, something that should have raised eyebrows, and when the same thing happened two more times, her clients began to suspect. However, for obvious reasons, they didn't want to go public so nothing was reported to the police.

Money was extorted from some of the more vulnerable lest their names would be "leaked" to the press. One man refused to be intimidated by extortionists. He was supposed to leave $100 at a predetermined spot, but when the pickup man arrived, a constable was there to meet him.

The pickup man squealed, and it turned out Con and Lil were getting 50 percent of the take from the robberies. Before the authorities arrived, the two pulled up stakes and moved to Bisbee, where she opened up a bawdy house in nearby Lowell.

The most enduring "haunted establishment" story in Tombstone history features the Bird Cage. It's the tragic love story of a shiftless, tinhorn gambler named Billy Milgreen and two prostitutes, Little Gertie the Gold Dollar and Margarita. All three were denizens of Tombstone's storied Allen Street.

Nobody except maybe Billy knew Gold Dollar's real name, and how she got it is a matter of conjecture. When the pretty little blonde first went to work as a dancer at the Crystal Palace, she called herself Little Gertie.

One story has it the name Gold Dollar was added because someone said her long, golden tresses were the color of a shiny new gold dollar. Another said it was because the price of a short-term love affair with her was a gold dollar. Whatever the case, she became Little Gertie the Gold Dollar. In a town where Lizzette the Flying Nymph, Big Nose Kate and Crazy Horse Lil also resided, her handle wasn't all that different from the others.

Gold Dollar was friendly, had an easy smile and was one of the most popular shady ladies in Tombstone. She was also a feisty gal, as later events of the love triangle would reveal.

All seemed well between Billy and Gold Dollar until Margarita, a tall, dark and willowy lady arrived in Tombstone. She took a job at the Bird Cage dancing and turning tricks. One night she laid eyes on Shiftless Billy and decided to put the moves on Gold Dollar's man. She figured she'd have

no trouble having her way with Billy, and physically, she'd have no trouble handling the diminutive blonde if it came to fisticuffs.

Gold Dollar couldn't help herself, she had fallen madly in love with Billy. When she could spare a few moments at the Crystal Palace, she'd steal away to where he was gambling and give him a hug and a kiss.

Meanwhile, Margarita was trying to get her hooks in Billy. She shamelessly flirted every time he stopped in at the Bird Cage. But what Margarita didn't know was Gold Dollar had friends who worked at the joint who kept her informed on Margarita's attempts to steal her man.

One evening, following a tip from one of her friends, Gold Dollar stormed in to the Bird Cage and caught Margarita sitting in Billy's lap. She grabbed a handful of Margarita's long, dark hair and threw her to the floor. The fiery Latina came up with fists flying. The Gold Dollar was no match for the larger woman so she reached for a stiletto stashed in her garter and stabbed Margarita in the heart.

During the confusion that followed, Gold Dollar slipped out the door and left town.

A doctor was called to the Bird Cage; he took one look at Margarita lying on the floor in a pool of blood and declared there was nothing he could do for the poor gal. He then proceeded to belly up to the bar for a shot of whiskey.

Margarita was laid to rest at Boothill on the west end of town. There are many today who believe the ghosts of one or both Gold Dollar and Margarita still inhabit the venerable old Bird Cage.

A few months later, Billy also left town. Some like to believe the two met in one of the many other raucous boomtowns.

There is a possibility that she quit the trade, met a nice young cowboy, got married and settled down, had a bunch of kids and lived happily ever after.

Not all the outrageous shenanigans occurred during the nighttime hours. There was also the great wrestling match staged in a manure pile in Bisbee between Irishman Biddy Doyle and the Cornish Cousin Jack.

Burt Alvord was a big strapping fellow with an IQ that was said to be somewhat less than his age. He did have a few positive attributes. He was usually cheerful, had a sense of humor and was a popular guy around Cochise County during the 1890s. He worked for a time as a deputy for Cochise County sheriff John Slaughter. Legend has it the sheriff said Burt didn't know the meaning of the word fear. He went on to say he didn't know the meaning of a lot of other words either. Burt's major interests seem to have been beer, poker, horses, guns and practical jokes.

Burt Alvord went from town prankster to lawman to famous outlaw and eventually to prison. *Courtesy of Scottsdale Community College.*

One time, he and a crony, Matt Burts, sent a telegram to Tombstone announcing, "The bodies of Burts and Alvord will be arriving on the Bisbee stage this afternoon."

Naturally, locals thought the pair had died in a gunfight. Many gathered in the local saloons that evening to raise their glasses and drink to a happy afterlife for the pair. A large delegation met the afternoon stage, but sorrow turned to chagrin when the mischievous duo emerged grinning from ear to ear, saying, "Our bodies have arrived. We never go anywhere without 'em."

Burt's most notorious prank occurred when Alvord and a little Irishman named Biddy Doyle, an ex-soldier, ex-boxer, ex-wrestler and practical joker extraordinaire, schemed to relieve the good citizens of Bisbee of their hard-earned cash by staging a fixed wrestling match. Boxing and wrestling were the most popular sports in the mining camps, and there was always a lot of money in the purse for the winner.

Biddy went over to Bisbee and found a local sharpie to act as promoter. They needed an opponent, so he found a muscular and not too bright Cornish miner who worked in the Copper Queen Mine. Before starting the betting, Alvord and Biddy needed to find a suitable spot for the match. The only soft spot was the mule manure piled outside the mine in Tombstone Canyon. In physical appearance, the little Irishman was no match for the big "Cousin Jack," but Biddy talked a good game and the crowd was betting heavily that the cocky little Irishman would lose. The odds quickly rose to twenty to one against Biddy. A large crowd of sporting men from Tombstone came to Bisbee to place their bets.

Burt Alvord and Biddy stood to make a small fortune if things went according to plan. Things might have gone smoother had they rehearsed a time or two so the fix wouldn't have looked so obvious.

Burt, who was acting as Biddy's trainer, bribed Cousin Jack to lose the match, then bet all their cash on Biddy to win.

The match never got past the first round. The two sparred briefly, and Biddy got behind the Cornishman and pushed his face down in the manure pile, causing the big man to surrender unconditionally. While the spectators were momentarily stunned, Biddy and Burt grabbed the purse containing several hundred dollars, ran to their horses and rode out of town in a cloud of dust.

Some of Tombstone's citizens took umbrage at the two mischief-makers, suggesting their scandalous behavior had tarnished the town's good reputation. Burt eventually became deputy sheriff for John Slaughter then a constable in Willcox where he formed a gang of train robbers and wound up doing time in the notorious Yuma Territorial Prison

Tombstonians would long remember the day a Gypsy strolled into town leading a bear on a leash. For five dollars, the miners could wrestle the bear. The bruin looked small, but when he stood, he was over six feet tall. The boys figured if they could lift one of his legs, the bear would be off balance and could be dropped to the ground. None could manage the feat, as the bear simply wrapped his front legs around the burly miners and gently laid them on the ground. Dozens of five-dollar gold pieces were bestowed that day.

Undaunted, the rough-and-tumble miners begged him to return the next day so they could have another tussle. However, the next day the Gypsy and his bear were nowhere to be found. Rumors quickly spread around town that the saloonkeepers, dance halls and gambling dens got together that night and paid him a handsome sum to leave town so the miners would return to their usual habits. Still, many claimed the wrestling bear provided the most fun the town had ever seen.

There was considerable rivalry between the copper mining town of Bisbee and Tombstone. Old-timers liked to tell of the huge man from Bisbee who came to town one day leading a mountain lion on a leash. He walked into a saloon, causing the imbibers to flee through the back door. "I thought you Tombstonians were tough," he bellowed.

There was only one man left standing at the bar. He reached inside his shirt, pulled out a five-foot-long rattlesnake and tossed it on the floor in front of the two interlopers. Both took off running and didn't stop until they reached the outskirts of Bisbee.

THE STRANGE BUT TRUE ODYSSEY OF SANTIAGO McKINN

On a balmy September morning in the little valley east of the Mimbres Mountains in southwest New Mexico, seventeen-year-old Martin McKinn and his eleven-year-old brother Santiago were herding cattle near their ranch on Gallina Creek, a tributary of the Mimbres River. The two McKinn boys were the sons of an Irish father, John, and their Mexican mother, Luceria. That morning, their father had gone to Las Cruces to purchase supplies.

It was about eleven o'clock on September 11, and the boys were taking a break for lunch. Martin was sitting beneath a shade tree reading a book, and Santiago had gone down to play in the creek. Suddenly, Santiago heard a rifle shot, and then he saw an Apache he later identified as Geronimo run up and crush Martin's head with a rock. Geronimo then removed his brother's shirt and coat and put them on. Santiago tried to run away, but the Indian and his companions caught him.

Searchers later found Martin's body, but Santiago was missing, something that gave them hope that he might be a captive.

Geronimo asked the boy questions in Spanish about the number of men and horses in the area, but the youngster was too traumatized to answer. They put him on the back of a horse and rode toward the Mimbres River.

Over the past few days, the wily sixty-three-year-old Apache shaman and his seven followers had been on a murderous raid, killing and pillaging along the valley east of the Mimbres Mountains. Before slipping into the Mogollon Mountains, they had ruthlessly slaughtered five men. A Mrs. Allen and her

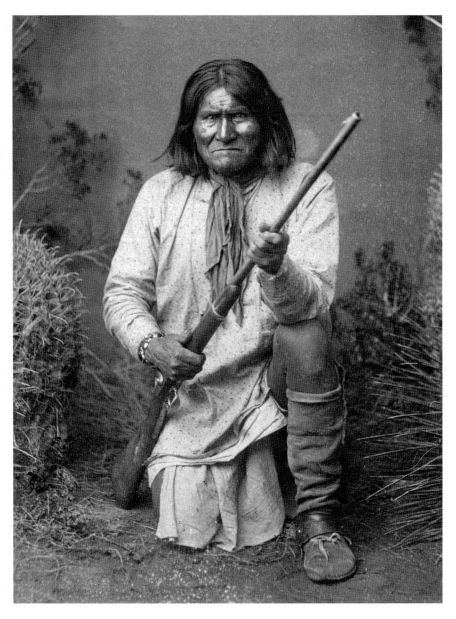

Apache war leader Geronimo putting on his game face for Tombstone photographer C.S. Fly at Canon de los Embudos. *Courtesy of Scottsdale Community College.*

three children escaped into the brush after her dog lunged at one of the warriors, momentarily distracting them. The warriors could have easily run them down, but Geronimo decided to loot the cabin for much-needed supplies. The war chief later said he knew the murder of a mother and three children would have created a worse outrage than the killings thus far. Mrs. Allen and her children then walked some eight miles to a sawmill operated by soldiers from nearby Fort Bayard.

By September 15, the Apache band had managed to elude cavalry troops from Fort Bayard and local militia, taking refuge high in the Mogollon Mountain wilderness—an area that was described as a "natural fortress."

At the time, Geronimo had no idea his bloody raid had stirred up a hornet's nest in both Washington and Mexico. Henceforth, Mexico would cooperate with U.S. troops operating south of the border, and the army was given full authority over the San Carlos Reservation.

In early October, the bands of Geronimo, Naiche, Nana and Chihuahua slipped past the soldiers guarding the border and made their way into Mexico's Sierra Nevada. Santiago McKinn was still with Geronimo's band. Over the next few weeks, the Apache bands continued raiding the Mexican settlements.

An American force commanded by Captain Emmett Crawford and Apache scouts crossed into Mexico and were in constant pursuit. After months of hard campaigning, on the morning of January 10, 1886, the scouts surprised Geronimo's camp. It was a short battle, and the old shaman had enough. He could elude the army, but the Apache scouts had found his most formidable sanctuary. He was ready to meet with General Crook to discuss surrendering.

Everything was going well, and it looked like the Geronimo Campaign was coming to a successful end when early on the morning of January 1, a force of 128 Tarahumara militia under the leadership of Major Mauricio Corredor approached. The major was known far and wide as the man who killed the great Apache leader Victorio at Tres Castillos in 1880.

Without warning, Major Corredor and his militia opened fire on the soldiers and scouts. Crawford, in full military uniform, believed the firing was a misunderstanding and ordered chief of scouts Tom Horn and two officers to investigate. He followed, waving a white handkerchief. They identified themselves as Americans, and soon the shooting ended. The soldiers and scouts had restrained their firing, causing Corredor to believe they were short on ammo. The Americans didn't know it at the time, but he had treacherous intentions. The two sides met in an open area. Crawford's

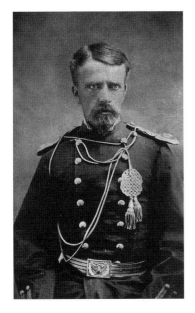

Captain Emmett Crawford was murdered in Mexico during a parley with Mexican irregulars. *Courtesy of Arizona Historical Foundation.*

chief of scouts, Horn was about one hundred feet in front of the two officers.

Horn, also waving a white flag, was ignored by Corredor, who brushed past him. When Corredor was just a few feet from the officers, he paused and looked around nervously. Standing behind the American officers on both sides were the Apache scouts. The Apache and Tarahumara were mortal enemies, and there was much trash talk going on between them, causing the officers on both sides to call for restraint. Crawford jumped up on a tall rock and waved his white flag again. One of Corredor's "peace party," who'd been designated to shoot Crawford, aimed his rifle and fired, hitting the captain in the forehead, mortally wounding him. Captain Crawford would die a painful death several days later.

Corredor smiled maliciously at Horn and fired, hitting him in the arm. All the members of the American peace party were fired on, but none of the others was hit.

Corredor tried to flee for safety, but Crawford's Apache orderly, Dutchy, fired, striking him in the heart. The scouts poured it on, killing nine of Corredor's treacherous ten-man "peace party." The Chiricahua Apache scouts bore most of the fighting that day and bravely held their ground. Their heroism would be told around Chiricahua campfires for many years to come.

On the morning of January 15, all the chiefs, Naiche, Chihuahua and Nana, agreed to meet with General Crook to surrender in one month at a place called Canon de los Embudos. The meeting took place on March 25, 1886.

It was the waning days of the so-called Geronimo Campaign. These were the last holdouts of a long war that had begun in early 1861. The great chiefs, Mangas Colorados, Cochise and Victorio, had all "gone under," and no other leader had risen who could bring the different factions together.

On the morning of March 26, Tombstone photographer C.S. Fly, who was traveling with Crook, got Geronimo's permission to take photographs.

On September 11, 1885, seven-year-old Santiago McKinn was kidnapped from the family ranch near the Mimbres River in New Mexico. In March 1886, he was discovered in Geronimo's camp. He was treated well by the Apache and had learned to speak their language. He cried when the army returned him to his parents. *Courtesy of Arizona Historical Foundation.*

While taking pictures of some youngsters, Fly discovered one of them was a white boy.

Apparently, Santiago had been well treated by the Apache, and during the six months he lived with them, he assimilated to their lifestyle and had become fluent in their language.

Captain John Bourke, Crook's aide-de-camp, would later write:

> *A group of young boys raged together freely and safely around; one of them seemed to be of Irish and Mexican descent. After a little persuasion, he told…that his name was Santiago Mackin [sic] and he had been kidnapped in Mimbres, New Mexico; of his young companions, he seemed to be treated kindly, and no one tried to stop our conversation….Beyond his smart looks which made it clear that he had fully understood everything we told him in Spanish and English, he took no further notice of us.*

Despite coaxing, Santiago refused to leave the Apache camp with any American. On April 6, Chihuahua brought the boy in and gave him to Crook, but the lad, "acting like a wild animal in a trap," insisted he wanted

to remain with the Apache. The soldiers tried to persuade him, but he would have none of it, defiantly refusing to speak any language except Apache. Young Santiago had become "*Indianized*."

The talks on March 28 seemed to be going well until that evening; some local whiskey peddlers, fearing an end of the war would seriously hamper their business, got Geronimo and his warriors drunk and told them they would be killed upon their arrival in Arizona. That night, Geronimo broke his word and bolted once again.

The Apache from other bands, along with Santiago, remained in camp. They were taken to Fort Bowie, where on April 2, they formally surrendered.

At Bowie Station, east of Willcox, Santiago, wearing only a "gee-string," got on the train with the others, headed for the prison camps in Florida. When the train stopped in Deming, New Mexico, his parents picked him up, got him outfitted in a local mercantile store and took him home.

Santiago grew to adulthood in Grant County, married Victoria Villanueva and had four children and eventually grandchildren. The 1930 census shows him living in Phoenix. According to family members, Santiago died in the 1950s in Phoenix.

AN OUTLAW'S CODE OF HONOR

Some outlaws had their lives glorified on the silver screen. Others often more deserving are mere footnotes in history. A few years ago, I wrote a story about an outlaw named Bill Smith, and shortly thereafter, I received a letter from one of his descendants, thanking me for keeping the memory of him alive.

During its day, the Bill Smith Gang was one of the wildest bands of desperadoes to ever ride those outlaw trails of Arizona and New Mexico. Maybe Hollywood wasn't interested in an outlaw named Smith when they had names like Ringo, Hardin, Bonney and Jesse James to choose from. Smith and his wild bunch would have been a match for any of them.

Captain Burt Mossman of the Arizona Rangers knew Smith about as well as anyone, and according to him, the outlaw chieftain had once been an honest cowpuncher who'd gone bad. According to Cap Mossman, nobody seemed to know why Smith turned his back on the law. Something he didn't spurn, as we shall see, was the chivalrous cowboy code of honor. He stood about six feet tall, had a slender, muscular frame with dark eyes and thick, coarse hair. The only flaw in his handsome features was a gap between his two front teeth. He was described as the kind of man who would arouse the interest of a "romantically inclined maiden." He was about thirty-five years old when he decided to turn outlaw. The ex-cowpuncher gathered around him a band that included his two brothers, George and Al, along with four other hard-bitten border desperados who would have followed him into the jaws of hell itself.

The story is that Bill Smith had drifted into the Oklahoma Territory in his younger days and ridden with the Dalton Gang. He was back in Arizona by 1898, caught rustling cows in Navajo County and jailed in St. Johns. His younger brother Al was able to slip a pistol into the jail, and one morning Bill appeared to be sleeping late when the jailer, Tom Berry brought his breakfast. Berry leaned over to awaken the outlaw and found himself looking into the receiving end of a .44 Colt. Smith locked the jailer in his own cell and slipped out the back way to a woodshed, where Al had left a Winchester and some shells. After his escape from the St. Johns jail, Bill Smith headed for New Mexico.

During the winter of 1900, the Bill Smith Gang terrorized most of southwestern New Mexico, holding up travelers and robbing stores. The brazen outlaws raided ranches and rustled livestock in broad daylight. Their fame spread far and wide, and before long, they were being accused of every killing and foul deed that occurred in the territory.

Finally, in desperation, the citizens of southwest New Mexico grew weary of lawful efforts to apprehend the gang and formed a vigilance committee that numbered several hundred. (New Mexico didn't have a territorial ranger force until 1905.) The manhunters were in the saddle constantly, scouring the rugged country along the Arizona–New Mexico line. Persistence paid off, as the relentless pressure soon drove the lawless bunch into Arizona. A new base of operations was set up in the remote Blue River country in northern Graham County, where Bill, along with his younger brothers, Al and George, was staying at their mother's place. When word spread that the Smith gang was now operating in eastern Arizona, Mossman dispatched four Rangers to the White Mountain area.

In early October, members of the gang were seen around Springerville. According to informants, they had robbed a Union Pacific train in Utah. On the way back to their lair on the Blue River, they stole a bunch of horses from a rancher named Henry Barrett. Barrett organized a small posse and rode to Greer, where they joined up with Arizona Rangers Carlos Tafolla and Duane Hamblin. Someone had spotted the gang near Springerville heading south, and one of the Smith brothers was seen buying supplies in St. Johns.

They picked up the trail near Sheep Crossing on the Little Colorado River and followed it over to the Black River. At Lorenzo Crosby's ranch, they recruited three more men: Crosby, Bill and Arch Maxwell. The Maxwell brothers, from Nutrioso, were experienced trackers and had been friends with Bill Smith until he'd stolen some livestock from them.

The posse followed the rustlers south, past Big Lake and from there back to the Black River. An early winter storm had buried the White Mountains under a thick blanket of snow. On the afternoon of October 8, they heard three rifle shots. The posse headed off in the direction of the shots and found patches of blood in the snow. The trail led toward a steep gorge.

Meanwhile, in a canyon near the headwaters of the Black River, Bill Smith and his gang had made camp. The boys were busy skinning a bear one of them had shot late that afternoon when one of the bloodhounds picked up a scent and started howling. Bill climbed to the top of the rim for a look and saw riders coming. He charged back to camp and sounded the alarm.

Meanwhile, the posse men picketed their horses some distance away and moved stealthily toward the abyss. The Rangers, Tafolla and Hamblin, along with Bill Maxwell, headed out across a clearing, while the other six took up positions on the edge of the rim. Barrett sized up the situation and called out for them to take cover. Hamblin dropped to the snow, but the other two kept moving across the clearing.

Tafolla and Maxwell found themselves caught out in the open looking down the rifle barrels of seven desperate men not over forty feet away.

Arizona Ranger Harry Wheeler, during an interview years later with the *Tucson Citizen*, gave a romanticized account of the conversation between Bill Smith and the two lawmen. According to Wheeler, Maxwell and Tafolla were alone when they heard three gunshots and, going to investigate, found blood on the snow where two men had killed an animal. They followed the trail to the outlaw's camp:

> *The two parties were now within forty feet of each other, Tafolla and Maxwell standing wholly unprotected by even a shrub, two dark spots against a snowy background of white. The outlaws were invisible except where each exposed a slight portion of his arm from behind the trunk of a great tree, supporting the protruding rifle barrels which were now leveled at the two exposed men. There was silence for a few moments as the two gazed coolly and calmly into the mouths of seven guns beaded upon them. Maxwell was the first to break silence,*
>
> *"Bill Smith," he said, "we arrest you in the name of the law and the territory of Arizona, and call upon you and your companions to lay down your arms."*
>
> *By this time standing erect, their bodies straight and motionless, their minds still cool and calm and their voices without a tremor, the utter*

fearlessness of the two officers, now wholly at the mercy of the outlaws, must have touched a spark of gallantry in the outlaw chief to which we have already referred. In Tafolla he had recognized a former companion of his days on the ranch, where they had worked together upon the range. Calmly he addressed his words to that officer.

"Tafolla," he said, "we know each other pretty well, I believe. We have ridden the range together in times past in better days than these—better than any which can ever come into my life again. We have spent many an hour of weary toil and hardships upon the plains and we have enjoyed many pleasures together. I liked you then and I like you still. For your own sake, for the sake of your wife and your babies, I would spare you now. I would also spare your companion. Go your way Tafolla. Give me the benefit of one day and I will leave here and never trouble this country again. But do not try to take me, for by God! I will never be taken—neither I nor any member of my party. Your decision must be made immediately for it is getting dark."

There was not the slightest deviation in the tone of Tafolla's voice from that used in demanding the surrender of the men when he made reply to the outlaw chief's proposal. If anything he spoke more slowly and more calmly than he did in the first instance.

"Bill, this friendship between you and me is a thing of the past. As for offering to spare our lives we may thank you for that and no more. For thirty days we've followed you, half-starved and half frozen. Now we stand together or fall together. The only request I have to make of you—and I make that for old time's sake—is that if Maxwell and I shall forfeit our lives here you will send to Captain Mossman the news and manner of our death.

Let him know that neither he nor the other members of the force need feel ashamed of the manner in which we laid down our lives on this spot this day. There is no more to be said; Bill, merely remember that a Ranger is speaking, and command you for the last time to surrender.

There was a brief fusillade of shots and all was over. The forms of Ranger Tafolla and Deputy Sheriff Maxwell lay huddled together in the snow. The men lived long enough to fight until their rifles were empty, for Smith for some reason perhaps he could not have analyzed himself, evidently strove to spare the men's lives, who so willingly died in trying to take his life. Dead shot that he was, he had placed three bullets in the hat of each man, just above the scalp, hoping, no doubt, that he would frighten the men into retreat without his having to kill them. But finding that he was dealing with men who had no fear of death, and having himself finally received a wound in his foot, he reluctantly lowered the range of his rifle.

Harry Wheeler, last captain of the Arizona Rangers, told the *Tucson Citizen* in 1907 he'd gathered the information from "Captain Mossman and others connected with the fight and pursuit." Part of Wheeler's story doesn't jibe with other accounts. It's hard to say what really happened in those frenzied moments before the fight.

Henry Barrett's account of the battle saw it a little differently.

According to Barrett, Maxwell called for the gang to surrender.

"All right," Bill Smith replied. "Which way do you want us to come out?"

"Come right out this way," Maxwell ordered.

Bill Smith boldy walked into the clearing, dragging his rifle, a new .303 Savage, behind, cleverly concealing it from the lawmen.

When he was about forty feet away, Smith jumped behind a tree, quick as a flash, raised his rifle and fired a round, hitting Tafolla in the belly. His rifle blazed again—the second shot hit Maxwell in the head. The fighting became general. A furious fusillade of gunfire echoed through that snowy basin. The rest of the posse opened fire from the rim. Smith dove for cover and returned fire with his men from behind trees. Hamblin was able to slip around to where the outlaws had picketed their horses. He turned loose nine saddle horses and a pack mule, leaving the gang afoot. The posse poured a withering fire down on the rustlers, forcing them to retreat into the thick woods as night fell.

When the smoke lifted and the outlaws had fled, the posse moved in. Maxwell lay dead in the snow, and Tafolla—hit twice in the belly—lay mortally wounded, begging for water. Tafolla, game to the end, kept firing his Winchester until he was out of shells. He would live in painful agony for several more hours before dying. Smith and one other outlaw had gunshot wounds. The little clearing would be known henceforth as Battle Ground.

It was said Bill Maxwell's bullet-riddled hat lay in the Battle Ground clearing for some time afterward, as the superstitious cowboys riding through the area refused to go near it.

Captain Mossman was at Solomonville when word arrived of the deaths of the two brave lawmen. He quickly organized a posse and recruited two Apache trackers, Old Josh and Chicken, from San Carlos.

The outlaws made their way to a cow camp on Beaver Creek, where they learned the identity of the other man killed in the clearing from the cowpunchers. Smith claimed to be remorseful at learning one of the men he'd killed was Bill Maxwell: "Well, I'm sure, sure sorry," he said. "When he stood up that way we thought it was Barrett, he was the one we wanted. We

feel mighty sorry over killing Bill Maxwell; he was a good friend of ours. Tell Bill's mother for us that we're very sorry we killed him."

Bill Smith and his gang headed for Bear Valley; east of the Blue River, they rode into Hugh McKean's ranch at suppertime and tried to buy some horses. Bill pulled out a roll of bills, but McKean wouldn't sell, so they took his horses, saddles, guns and a sack of grub at gunpoint and headed for New Mexico. Again, Smith said he was sorry he'd killed Bill Maxwell but was glad he'd killed a Ranger.

Mossman's Apache trackers followed the trail to the McKean ranch, arriving a day after the outlaws had ridden east. Mossman and his Rangers kept up the chase until they were driven back to McKean's ranch by another snowstorm. When the weather broke, the Apaches picked up the trail again, heading toward Magdalena, New Mexico. Mossman stubbornly continued the chase all the way to the Rio Grande before losing the trail for good near Socorro.

The Arizona Rangers' persistence paid off. The Bill Smith Gang was driven out of Arizona for good. Smith's mother later told one of the Rangers that Bill and Al went to Galveston, Texas, and took a boat for Argentina. Several years later George, turned himself in to Graham County sheriff Jim Parks. The only charges against him were in Apache County, so he was turned loose. He went back to live on his mother's ranch near Harpers Mill on the Blue River.

The rest of Bill Smith's life is a puzzle. Frazier Hunt, Mossman's biographer, said that Smith shot Ranger Dayton Graham in Douglas. Graham survived and later hunted down and killed the outlaw. But that seems to be a case of mistaken identity. Did Bill Smith stay in Argentina, or did he return and assume a new identity? If his mother knew, she never said.

Hunt also wrote that Bill Smith later sent a letter to Mossman detailing those last brief moments in the lives of lawmen Tafolla and Maxwell. It that's true, then despite the fact that Bill Smith turned his back on society and became one of the most ruthless desperados of his time, he maintained code of honor that bonded those men of the breed.

TUBAC, TUMACACORI TO HELL

Pete Kitchen represented Arizona's transition from a savage, lawless frontier to civilization. He came to Arizona in 1854, settling in the new Gadsden Purchase just north of the Mexican border on Potrero Creek near its junction with the Santa Cruz River.

In 1861, the U.S. Army was withdrawn from Arizona to fight in the Civil War that raged in the East. The Apache and lawless elements on both sides of the border seized the opportunity to ravage the settlers in Arizona. Travelers were murdered daily on the roads leading out of Tucson. The bloody road that passed by Pete's ranch was christened, "Tucson, Tubac, Tumacacori, to Hell."

Pete's ranch on Potrero Creek became the only safe haven between Tucson and the Mexican village of Magdalena. Located atop a hill with a commanding view in all directions, his ranch house became a veritable adobe fortress. The flat roof on the adobe house was surrounded by parapet three to four feet high, and a sentinel was always on duty there to give warning of an attack. Another was posted with the herd. If an attack came, he would fire his rifle as a signal for the herders and farmworkers, who would run for the house. At the same time, Pete and his wife, Dona Rosa, would gather the rifles from the racks and lay them out to be ready to grab and shoot. It was extremely difficult for an enemy to approach, and Pete had a sixth sense about Apache warriors and border bandits.

The ranch also sat on a main Apache plunder trail along the Santa Cruz River, five miles north of present-day Nogales.

Pete Kitchen, rawhide tough, fought off the Apache from his hilltop bastion. *Courtesy of Scottsdale Community College.*

With the Apache on one side and Sonoran bandits on the other, the ranch was under siege much of the time. Despite the danger, Pete and his hired hands raised corn, cabbage, potatoes, fruits, melons and hogs on over one thousand acres of rich bottomland. His hams were famous throughout the southern part of Arizona and New Mexico.

Pete Kitchen was born in Covington, Kentucky, in 1822. He served with the U.S. Mounted Rifles during the Mexican War and arrived in Tucson in 1854, the same year the Old Pueblo became part of the United States. During this time, Pete became an expert marksman with a pistol and rifle. He once put a bullet through an Apache warrior from six hundred yards away. Dona Rosa was said to have been nearly as good with a rifle as he was. When the alarm was sounded, she would tie up her skirts so they fit like trousers, grab her rifle and give the Apache a reception as hot as the chili she served. Together, they and their employees defended their ranch from the banditry and Apache alike.

The ranch had its own "boot hill," where Apache and bandits alike were buried. Dona Rosa, being a good Catholic, burned candles on their graves.

The Apache made many all-out attacks in an attempt to drive him out. They murdered Kitchen's twelve-year-old stepson and killed his foreman. Several times they tried to burn his house, and once they made three major attacks within a twelve-hour period. All were driven off by Pete, Rosa and the rest of his sharpshooters from behind the parapet on the roof of his ranch house. Finally, in frustration and to restore some lost pride, they did something that must have annoyed Pete more than anything else they could have done. They began shooting arrows into his prize hogs, turning them into, as one observer noted, "walking pincushions."

The Apache did everything they could to drive him away but there he stayed—unconquered and unconquerable. He was the only settler in the Santa Cruz Valley they couldn't dislodge.

Pete and his outnumbered outfit of Mexicans and Opata Indians stubbornly fought back against their relentless foe until sometime in 1867, when the Apache decided to alter their plunder trail and cut a wide circle around his ranch. At length, they came to recognize Pete as an enemy worthy of their respect and a man better off left alone.

He beat the Apache at their own game, on their own ground, and they knew it.

A MIRACLE IN THE WILDERNESS

With the exception of Tucson, southern Arizona was virtually abandoned by Americans in 1861, when the military posts were abandoned and the army was withdrawn due to the Civil War. With no soldiers to police the region, Apache war parties roamed the hills and mountains, raiding at will. It was dangerous to travel outside the walls of the Old Pueblo.

The Penningtons were the first American family to settle along Sonoita Creek. The family patriarch, Elias Pennington, moved his family from Tennessee to settle in the northeast part of the Republic of Texas in 1839. For the next fifteen years, they farmed, and he also freighted goods to Louisiana. But he was a restless soul and thought northeast Texas was getting too crowded. Over the years, his family had grown, and he wanted more space. He now had eight girls and four boys.

So, Eli set out to the Brazos River country, where he found some good land, but when he returned to fetch his family, he found his wife, Julia Ann, had passed away, leaving him with a large family to raise. He decided to move to California, where they could get a fresh start, so he and his children joined a wagon train bound for the Promised Land.

They traveled west across the vast Texas hill country and plains, crossed the Pecos River, passed through El Paso and headed toward what would one day be Arizona, passing through Doubtful Canyon, Apache Pass and Dragoon Springs. They forded the San Pedro where the town of Benson is today.

In June 1857, they arrived at Fort Buchanan, a post recently established, on Sonoita Creek. It was good cattle country, and the nutritious grass grew shoulder-high in some places. The game was plentiful, but hunting was dangerous for fear of roving bands of Apache.

The Penningtons decided to withdraw from the wagon train and remain in the beautiful area along Sonoita Creek.

For the next couple of years, Eli ran a small freighting business and supplied hay for the fort. His eldest daughter, Larcena, caught the fancy of most of the young soldiers at the fort, but none was able to win her heart. The lucky guy who did was John Page, a handsome rounder who'd arrived in Tucson in 1857 with the notorious Texas gunfighter Jeff Ake.

On Christmas Eve 1859, twenty-two-year-old Larcena, the prettiest of the

Larcena Pennington was among the first white women to settle in Arizona. She survived her brutal capture by Apaches, but the Pennington family's Arizona adventure came at a terrible cost. This photo was taken ten years later. *Courtesy of Arizona Historical Foundation.*

Pennington girls, married Page. The wedding was a memorable event, as it was one of the first American weddings in the Old Pueblo.

The following March, the couple moved to Bill Kirkland's ranch at Canoa, thirty miles south of Tucson. Kirkland also had a lumber business in the Santa Rita Mountains that supplied both Fort Buchanan and Tucson. John went to work with his friend Bill Randall, cutting timber at the lumber camp in Madera Canyon thirteen miles east of Canoa while Larcena tutored ten-year-old Mercedes Sais Quiroz, the daughter of a Mexican widow in Tucson and a ward of Kirkland's, teaching her to read and speak English.

The mosquito-infested valley along the Santa Cruz River turned out to be unhealthy for Larcena and brought on a reoccurrence of "mountain fever" she'd contracted earlier at Fort Buchanan, so on March 15, 1860, she and Mercedes boarded an oxcart and moved up to the lumber camp near the mouth of Madera Canyon near a small stream, where the cool mountain air was much better for her health. She brought with her a rocking chair and a feather bed; both were wedding gifts from Kirkland.

The morning after their arrival, her husband had gone to the pinery, and Randall had gone off to hunt deer. Five Tonto Apache, far from their

usual haunts north of the Gila River, struck. They had been watching the camp since the day before. Mercedes was outside the tent when an Apache rushed up and grabbed her. Larcena's dog began fiercely barking. Larcena, who was inside the tent, heard the girl's terrified scream. Suddenly, the tent flap opened, and an Apache warrior rushed in. She tried to reach for the revolver hidden beneath the bed covers, but he quickly grabbed her, took the pistol and pushed her outside.

There, Larcena found herself surrounded by four more warriors, armed with lances, bows and arrows. All of them were quite young, except for the one who burst into her tent. She attempted to scream for help but hesitated when one pressed his lance against her breast.

While Larcena and Mercedes stood terrified, the Apache looted the tent, scattering provisions and generally trashing the area. They amused themselves by cutting open the flour sacks. When they'd finished their mischief, they gathered what they could carry—as they were traveling on foot—then headed north with their two captive girls. One had gathered up the feather bed, taking it as booty, but found it cumbersome, so he sliced it open, scattering feathers to the wind.

Around noon, Randall returned to the camp, found it had been plundered and Larcena and Mercedes missing. He rode hard back to Canoa and alerted Kirkland, who sent a rider to Fort Buchanan while he rode to Tucson for help. Back at the lumber camp, Page gathered some friends and picked up the trail.

The next day, Captain Ewell and a detachment of Company G, First U.S. Dragoons, rode north from Fort Buchanan to try to catch up with the Apache band.

The warriors and their two captives followed a trail in a northeasterly direction. Along the way, Larcena, already a veteran of life on the frontier, broke off twigs and tore off small pieces of cloth from her dress, marking a trail for their rescuers. The braves were in too big of a hurry to further molest the captives or take notice of Larcena marking their trail.

Climbing the steep hills in the Santa Ritas began to take its toll on Larcena, and toward the end of the long, tortuous day, they paused on top of a high ridge. One member of the band had been left behind to act as rear guard. He rushed forward and told the others they were being followed by white men.

Earlier that day the older Indian had taunted Larcena by pointing the revolver he'd taken at her head. Mercedes heard him say, in broken Spanish, they were planning to kill her.

He motioned for to take off her dress and shoes. She was clad only in a thin chemise and petticoat and was barefoot. He motioned again for her to take the lead. As she walked in front of the group, she felt the sharp pain from a lance that he thrust in her back. As she fell forward down the steep grade, two of them followed along, hitting her with rocks and piercing her with their lances. She crashed into a pine tree. As she lay there, one picked up a large rock and slammed it against her head.

Believing she was dead, they dragged her body behind a tree and left her lying in a bank of snow.

Sometime later, she regained consciousness and heard her husband's voice and the barking of her dog at the top of the hill. She tried to call out, but her voice was too weak. Then she heard them leave, believing they were hot on her trail. One of the Apache was wearing her shoes, causing her husband and the others to believe Larcena was making those tracks.

She lost consciousness again and lay there at the foot of the tree for three days. When she awoke, she attended to her wounds as best she could and swallowed some melted snow to slake her thirst.

She looked out across the Santa Cruz Valley and recognized a familiar landmark, Huerfano Butte. She would use it to find her way back to the Madera Canyon. She knew that trying to climb back up to the trail would be impossible, but now she knew the general direction back to the camp and made her way down the slope. She figured she had traveled at least a dozen miles after she was taken.

Day after day she crept, supporting herself with her hands and subsisting on seeds, berries, wild onions and melted snow. The nights were freezing cold and the days witheringly hot. At one point, she found a soft grassy area and decided to bed down for the night, but when she discovered she was in a bear's den, she quickly crawled away.

For days, she slowly made her way back toward the camp, her bare shoulders blistered from the sun and her bare feet pierced with stones. Blood clots covered her head. Still, she plodded southward, crawling or walking on all fours until she came to a ridge that looked down the road leading into Madera Canyon, where she saw some men with an oxcart. She tried to call out, but her voice was too weak, so she took her petticoat, tied it to a stick and waved it like a flag. But they drove on without seeing her.

Two days later, Larcena walked into the camp from which she'd been taken more than two weeks before. It was now abandoned, but she found coffee and flour scattered on the ground. She gathered up some flour and

mixed it with water from the creek, then built a small fire and baked herself some bread. Afterward, she bathed her wounds in the stream and, feeling somewhat refreshed, slept.

The next morning, she awoke to the sounds of people talking. She crawled in that direction and made her way to the woodcutters' main camp in the canyon. The first person to see her was the camp cook, a black man from Texas named Hampton Brown. At first, he thought the spooky apparition crawling toward him was the spirit of some poor dead soul.

In barely audible voice, she said, "I'm Larcena Page."

He reached down, picked her up and carried her into camp. At first, they didn't recognize her. Larcena was bloodied, sunburned and emaciated. The first thing she asked for was a chaw of tobacco.

A courier was sent to Tucson to fetch a doctor. Word of her miraculous survival reached her husband, John, just as he was planning his third expedition to find her. He'd followed the trail to the Rincon Mountains, east of Tucson to the Catalinas, never giving up hope of finding her alive despite the fact he'd learned through the Apache grapevine that she was dead.

The doctor from Tucson arrived and believed she was going to die, but John put her in a wagon and drove to Tucson, where, in time, she made a full recovery.

Captain Ewell was able to negotiate Mercedes's release in exchange for some Apache prisoners.

There was a huge celebration in the Old Pueblo when the little girl returned with Kirkland. The church bells at San Augustine were ringing, and the citizens applauded as she was returned to her grateful mother. The citizens also hailed the tireless efforts of Captain Ewell, Bill Kirkland and John Page for her safe return.

Many believed the older Apache who spoke broken Spanish was Eskiminzin, a Pinal Apache who married into the Aravaipa and later became their chief. Their village was located where Aravaipa Creek joined the San Pedro River northwest of Tucson. He was well known to struggle with the truth, but he played an important role in the ransom and return of Mercedes. The trail led directly to his camp, but he denied having the little girl. He could, however, secure her release from those who had her, if Captain Ewell would exchange the twenty Pinal Apache captured in an earlier skirmish with the Dragoons. Ewell agreed to the lopsided prisoner exchange, for the child's safe return was far more important. Bill Kirkland was present, and Ewell loaned him his horse to take the youngster back to Tucson.

Bill Kirkland was one of the first Americans to arrive in Arizona. He raised the first American flag over Tucson following the Mexican army's evacuation in 1856. At the time, there were only seventeen Americans in the Old Pueblo. *Courtesy of Scottsdale Community College.*

Several years later, on April 30, 1871, a punitive expedition made up of Tohono O'odham Indians and Tucsonians raided Eskiminzin's village in the infamous Camp Grant Massacre.

By 1859, the Pennington family was living on a small ranch near the old town of Calabasas, just a few miles from the storied Pete Kitchen's fortress ranch. Their farm came under attack from bands of Apache many times, and the girls often had to help their father and brothers fight off the raiders. Eli Pennington stubbornly refused to abandon his ranch, declaring he had as much right to the land as the Apache. If they wanted to cross his place on their traditional plundering forays into Mexico so be it, but like his neighbor Pete Kitchen, he was going to fight to protect his family and his property.

Frequently, in his absence, it was said his brave daughters were left to fight the raiders on their own.

Larcena and John had tried to put their lives back together, but tragedy struck again. In 1861, John was ambushed and killed near Canyon del Oro by a band of Apache. He was buried where he fell, and Larcena never got a chance to view his body. She was three months pregnant at the time. She was given a handkerchief, his wallet and a lock of his hair.

Larcena went back to live with her father at his ranch on the Santa Cruz River, but because of the frequency of Apache attacks, they were forced to live in a mine shaft near Patagonia. That coincided with an epidemic of smallpox. In all this mayhem, Larcena gave birth to her baby, whom she named Mary Ann.

The Penningtons continued to move often. In 1864, they were living in the abandoned town of Tubac. Tragedy continued to plague the family. Three years later, Larcena's sister Ann died of malaria. Tragedy struck again in June 1869, when Eli and his son Green were killed by Apache warriors while working in their fields at the ranch on Sonoita Creek. Eli was killed instantly, but Green lingered on for eight days before succumbing to his wounds. A year earlier, another of Larcena's brothers, Jim, was killed in an Apache ambush in the hills west of Tucson.

The remaining members of the family moved to Tucson and planned to go on to California when another sister, Ellen, fell ill and died of pneumonia.

In 1870, another brother, Jack, rounded up his unmarried sisters and herded them back to Texas, away from Arizona's dark and bloody ground. Larcena remained in Tucson, and that same year, she married William F. Scott. She bore him two children and lived the rest of her life in Tucson, passing away on March 31, 1913, at the age of seventy-six.

Pennington Street in Tucson is named for Larcena's family.

Mercedes grew up to be a beautiful woman, and in 1868, she married Charlie Shibell, who was sheriff of Pima County during the turbulent times of Wyatt Earp and the Gunfight at O.K. Corral. Sadly, she died in 1875 of complications following the birth of her fourth child at the age of twenty-six.

The story of Larcena Pennington Page is one of raw, undaunted courage and perseverance. Western writer Louis L'Amour used to say it "took men with bark on" to survive the rigorous life in the Old West. The story of Larcena Pennington Page clearly shows the same could be said of those hardy frontier women.

THE LAWYERS OF ROTTEN ROW

Tombstone, like other mining towns in the West attracted some of the most talented attorneys in the country, especially those who saw the boomtown as an opportunity to get a "fresh start."

Next to the saloons, litigation became the single most lucrative business in a mining camp, and some of those early lawyers were the best money could buy. They weren't always welcome. One prospector observed, "We didn't need laws until the lawyers got here."

Tombstone's lawyers occupied offices along a row of buildings on Fourth Street between Toughnut and Allen Streets on what was somewhat affectionately known as "Rotten Row." The Row was conveniently located between the saloons and courthouse. The area overflowed with whiskey and oratory when court was in session.

Tombstone's lawyers were as colorful a bunch of characters as any of the other denizens who took up residence in Arizona.

One who stood out among the rest was Ben Goodrich. He didn't drink, gamble or patronize the good-time girls. He didn't even go to church. In fact, he had no vices at all. However, Tombstonians tolerated one and all, and the rest of the occupants of Rotten Row did their best to make up for his eccentric ways.

His partner was the colorful Marcus Aurelius Smith, a tall, handsome Kentuckian with a magnificent walrus mustache that hung down to his chin. Everyone knew and liked him.

Mark Smith, a tall, handsome, luxuriantly mustached Kentuckian, practiced law on Tombstone's so-called Rotten Row. When Arizona gained statehood in 1912, Smith was elected to the U.S. Senate. *Courtesy of Scottsdale Community College.*

Smith was a compulsive gambler. One evening, while in his cups, he scoured the saloons on Allen Street looking for a game of particular chance called bank. He eventually found what he was looking for in the Pony Saloon, where two transients were dealing a game called brace using a crooked box.

When some of Smith's cronies heard about what was happening, they beat a path to the Pony, warning him the game was crooked and he didn't have a chance to win.

"Who cares," he scoffed. "It's the only game in town!"

In 1887, Mark was elected to Congress as Arizona's territorial delegate, and he played an important role in the territory's quest to become a state. Things looked bad in 1905 when Congress tried to force Arizona and New Mexico to join the Union as a single state. As a territorial delegate he had no vote, but with a bit of shrewd politicking, he attached an amendment to the Joint Statehood Bill that both territories must approve the measure. New Mexico voted in favor, but Arizona overwhelmingly voted against it. Singlehandedly, Mark outfoxed those Eastern politicos, and in 1912, Arizona was granted statehood, becoming the last of the contiguous territories to join.

William Staehle was known as the German Warrior or "Ol' Corkscrew," as he was gifted with miraculous powers of absorbing of any kind of spirits. The gregarious and popular Staehle was a skilled violinist, too, and Mendelssohn was his favorite composer. Strangely, nobody remembers what talents he might have possessed as an attorney.

He was married to a woman named Gussie who had a wandering eye and eventually left him for the bright lights of San Francisco. He ran for office once and was elected district attorney but was drunk throughout his tenure and lasted only one term.

One evening, some soldiers from Fort Huachuca got into a brawl in the Crystal Palace, and the German Warrior decided to join the fracas. Raising his forefinger in the air, he declared, "Count me in."

A moment later, a stray punch caught him on the jaw and put him flat on his back. He managed to raise a forefinger once more, saying, "Count me out."

One night he was on the prod in an Allen Street saloon and the bartender gently led him to the door and gave him a gentle kick in the seat of the pants.

"I didn't mind getting kicked in the seat of the pants," he indignantly howled to the denizens of Allen Street, "but the dirty son-of-a-gun kicked me in the seat with a pair of dollar and a half shoes."

The greatest of them all was Allen R. English. During his best years, nobody could match him in the courtroom for skill, wit and jury persuasion. An old-timer recalled he once got a case of sodomy reduced to following too close.

The scion of a wealthy family in Maryland, he graduated from law school

Allen English earned a law degree at the age of nineteen. Drunk or sober, he was one of the Arizona Territory's most brilliant attorneys. *Courtesy of Scottsdale Community College.*

at the age of nineteen but had a difficult time fitting in with the social circles of Maryland. A year later, he landed in Tombstone and went to work as a hard-rock miner. Allen Street wasn't named for Allen English, but for John "Pie" Allen, a prominent businessman in Tombstone. Allen made his first fortune and his nickname baking pies and selling them for a dollar.

While perusing the Allen Street saloons, English made the acquaintance of Mark Smith, who quickly recognized his talent, and he was soon a full partner in the firm of Smith and Goodrich.

He made a fortune in fees from the big mining companies, but he spent it as fast as he got it. English was a good lawyer drunk or sober, but most agreed he was better while in his cups.

One time he was defending Wily Morgan, who was charged with murder. Just before closing arguments, there was a two-hour recess. English headed for the nearest saloon for more of the hair of the dog that bit him, and two hours later, he was passed out on the barroom floor.

The boys sent for a horse and buggy at the O.K. Corral to haul him back to the courthouse. They carried him up the stairs and propped him up to make his final appeal to the jury.

English braced himself, took a deep breath and faced the jury. For the next two hours, he delivered a sermon that included his entire vocabulary. When the jury returned a verdict, Wily Morgan was a free man. As for English, he had no idea where he was or what he'd just accomplished.

People came from miles around to watch this courtroom colossus in action. He'd approach the jury, call a juror by his first name and ask for a chaw of tobacco. He directed juries like a conductor leads a symphony, moving about the courtroom with the grace of a cat, pleading one moment and indignant the next. He could shed tears and talk of motherhood. His clever courtroom antics and florid use of the English language made him popular with spectators and juries, but he was a nemesis for judges and prosecutors alike.

A courtroom novice once remarked, "My goodness, that Mr. English is certainly an outspoken man."

A weary prosecutor replied, "Mr. English may be out-thought, out-maneuvered, out-smarted but believe me, he is never out-spoken."

THE OLD BLACK CANYON STAGECOACH ROAD

King Woolsey was one of Arizona's most prominent pioneers during the 1860s and 1870s. He prospected for gold in Arizona before the Walker Party arrived in 1863. He earned a formidable reputation as an Indian fighter, rancher, businessman and politician. He also owned a flour mill at Agua Caliente on the Gila River. One day in 1869, he rode over to the stage station at Gila Bend about the same time as a wagon train arrived.

A woman named Mary was a member of a group of migrants bound for California. She was traveling with a man named Nash to whom she wasn't married; however, as was custom, her fellow travelers discreetly referred to her as "Mrs. Nash." Apparently, the pair weren't getting along too well, for she'd written in her journal: "I was tard of the trip, my husband and I had been fussin'."

At Gila Bend, a handsome, dark, rugged-looking man caught her eye. In a soft southern drawl, he introduced himself as King Woolsey.

Their courtship was brief—Woolsey didn't even take time to get down off his horse. After a few words, Mary climbed up behind him, and the two rode off into the sunset.

During her years with Woolsey, Mary had a number of adventures. Once, she single-handedly captured a notorious outlaw. The two remained together until King's death ten years later at the age of forty-seven. Mary went on to have a successful business career investing in ranches and real estate. She accumulated a fortune of more than $2 million, and when she died in 1928, Arizona flags flew at half-mast.

King Woolsey is credited with bringing the first wagon up through the Black Canyon in the mid-1860s. He had a ranch on the upper Agua Fria River, where Dewey is located today. Woolsey also led several punitive expeditions against raiding Indians during that period. The adobe ruins of Woolsey's station can still be seen today on the old Black Canyon road between Dewey and Humboldt.

The earliest stagecoach road connecting Prescott with the old Gila Trail from Tucson to California headed south and west from Prescott, bypassing the tiny community of Phoenix. It had the advantage of flat desert country most of the way. At the time, Wickenburg was the hub of traffic to points west. That changed when the future capital city began supplying large amounts of hay and food to Fort Verde and Prescott.

The idea for a wagon road from Phoenix to Prescott by way of the Agua Fria River was first proposed in 1866. Both the army and local businessmen wanted a more direct road between the two towns.

In 1870, John Marion, colorful editor of the *Prescott Miner*, was traveling with Colonel George Stoneman, commander of the newly created Department of Arizona, on a tour of the territory. Marion's journal vividly recorded the tremendous difficulties encountered while climbing the steep, boulder-strewn Black Canyon. Despite this, the editor recognized the importance of building a wagon road and continued to press the matter. Funds were raised, and in November 1873, the first wagon train completed the ninety-five-mile journey on the new road in just five days, half the time it would have taken on the Wickenburg road. Although a stagecoach could make the trip from Prescott to Phoenix in a day and a half, it took the heavy mule-driven freight wagons a week.

Rock Springs gets its name from a nearby spring. The community came into existence in 1922 when Ben Warner put up a tent store to serve miners, prospectors and motorists. He later built a permanent hotel, restaurant and store.

The area surrounding Rock Springs and the old stagecoach road that eventually became an interstate highway is chock-full of rich Arizona history. During the 1860s, Rock Springs was mentioned often in the journals of cavalry troops passing through the popular watering spot on their way from Fort McDowell to Fort Whipple.

West of Rock Springs are the sprawling Bradshaw Mountains. These brawny mountains yielded many fortunes in gold and silver. Their name comes from two prospectors, Ike and Buck Bradshaw. In the fall of 1863, they made a big strike, and a new mining district was named for them. In

1871, a townsite was laid out, and Bradshaw City was born. It only existed for a year, but during the town's brief heyday, some five thousand residents called it home.

During the mid-1870s, huge silver deposits were found west of the Agua Fria River. The Tip Top mine opened in 1876, and two years later, the mill town of Gillett was founded along the Agua Fria a couple of miles south of today's Rock Springs.

Soon after the mine at Tip Top opened, some two hundred miners, including eight women and fifteen youngsters, settled in the camp. It was well supplied with a grade school, two general stores, six saloons, two restaurants, a Chinese laundry, a blacksmith shop, a butcher shop and even a shoe store. Except for a few renegade Indians still prowling the Bradshaw Mountains and border agents who infested the area hoping to rob the Black Canyon stagecoaches, Tip Top was a nice little community.

Between June 1883 and June 1885, outlaws held up the stagecoaches between Gillett and Black Canyon City six times.

The blacksmith in Gillett was making some good money moonlighting as a stage robber until he made a careless mistake. He'd held up the stage at Squaw Creek Canyon several times, and by the time the coach arrived at Gillett, he was back in his shop. Wells Fargo sent a detective to Gillett to do some investigating. One night, he was watching a poker game in one of the town's saloons. The blacksmith was on a losing streak, so he excused himself, returning a few minutes later with a pocket full of gold coins, and resumed play. The coins were dripping wet and covered with mud. Naturally, the detective became suspicious, and a search was made of the shop. The blacksmith, after a little persuasion, confessed and led the detective to his cache of gold coins stashed in the bottom of the quenching tub.

The camp was fairly peaceful even though among the inhabitants were former Confederate and Union soldiers. Two men died in gunfights, another was struck by lightning and the fourth expired from a centipede bite. The unfortunate fellow pulled on his boot one morning, and the critter bit him on the toe. Since whiskey was the usual panacea, he rushed down to the nearest saloon, gulped down a quart of the firewater and promptly keeled over dead. His passing was more likely from the overdose of whiskey rather than the centipede bite.

Tip Top finally got its own post office in 1880. Up to then, the citizens had to pay thirty dollars a month to have their mail delivered from the mill town of Gillett, some eight miles away.

Two years after the silver discovery at Tip Top, a buckboard began carrying passengers north from Phoenix to Gillett. A one-way ticket cost five dollars, and a round trip cost eight. A month later, a stagecoach from Prescott made its first run headed for Gillett. A one-way ticket on the stage cost ten dollars.

The Prescott-bound stage also made stops at the New River station, the Agua River crossing at Cañon (near today's Rock Springs), Bumble Bee, Cordes (Antelope), Mayer (Big Bug), Dewey (Spaulding's and Agua Fria) and Four-Mile Hill, just east of Prescott.

Darrell Duppa, the English gentleman credited with naming both Phoenix and Tempe, ran the New River station for a short time. A few years earlier, "Lord" Duppa, as he was called, had one of the more bizarre encounters in the history of frontier Arizona when he suddenly came under attack by a band of Yavapai warriors. During the fight, he lined one up in his sights and pulled the trigger, hitting the brave, who let out a painful yell and fell among the rocks. The others withdrew, leaving their companion behind, and as Duppa approached, a voice cried out in English.

"Don't shoot!"

To his surprise, Duppa noted that the fallen warrior was a thirty-year-old white woman dressed in all the paint and paraphernalia of the local Yavapai and Apaches.

The woman died before revealing any clues as to how she came to live among the natives.

There were a few instances where white men went native and joined warrior bands, but white women warriors were rare in the annals of western history. Lord Duppa's stagecoach station at New River, is still operating as a store and café, can be seen on the east side of I-17.

During the late nineteenth century, the Arizona Stage Company made the run from Prescott to Phoenix on the Black Canyon road every Monday, Wednesday and Friday. The return to Phoenix was Tuesday, Thursday and Saturday. Later, the company made daily runs both ways. The Prescott-Phoenix stage took about thirty-six hours to complete its journey, passing from elevations of 5,200 feet to 1,000.

The southbound stage left Prescott at 8:00 a.m. and arrived at Phoenix around noon the following day. A one-way ticket cost $12.50, cheaper than the Wickenburg route and ten hours faster, but the ride was rougher.

Travelers on the stagecoach road had to be on constant guard for broken axles, flash floods, quicksand, runaway stages and highwaymen. The road was treacherous and dangerous. Antelope Hill, between Bumble Bee and

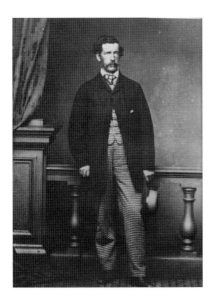

Englishman "Lord" Darrell Duppa, the man who named Phoenix and Tempe. Exiled by his family in England for excessive drinking, he made a name for himself in early Arizona. *Courtesy of Arizona Historical Foundation.*

Cordes, was the most arduous, with steep, winding switchbacks. Another steep climb was Black Canyon Hill, just north of the Agua Fria crossing. The old road is still visible to travelers on I-17. Stagecoach drivers used to announce their arrival at a hairpin turn with a shrill blast of a tin horn. A driver coming from the other direction replied with two blasts. If the two rigs met in a place too narrow to pass, it was customary for the driver on the downside to unhitch his team and ease the wagon downhill to the first wide spot in the road. The steep grades provided an ideal place for stage robbers.

The stage road ran along New River, west past Table Mesa and on to Gillett. The next station up the road, located on the south bank of the Agua Fria River was Cañon. Most likely, the first station keeper was Jack Swilling, who arrived in the early 1870s and was prospecting, mining, ranching and road building. It was sometimes called Black Canyon or Goddard for a station keeper who was murdered by bandits in 1903. Rock Springs is located a mile south of the station.

A newspaper article dated November 15, 1892, described a harrowing experience of another kind on the Black Canyon Stage Line. The stage left Prescott with a foot of snow on the ground. On board were the colorful former sheriff of Yavapai County Buckey O'Neill; Price Behan, the father of Johnny Behan, sheriff of Cochise County during Tombstone's tumultuous years; two Catholic nuns; and Will C. Barnes, who told the story.

The stage was headed up Four Mile Hill, also known as Virgin Mary Hill, east of town, when the passengers noticed the driver was drunk. On the downhill side, the stage picked up speed and was out of control. Behan and O'Neill climbed on top of the stage and wrestled control from the drunk driver. O'Neill plunked him upside the head with the barrel of his six-shooter, and they handcuffed and bundled him in the boot of the stagecoach.

At Mayer, they left him behind, and Behan and O'Neill took over the stage. As the elevation dropped, the snow disappeared, and mud and rain took its place.

When the stage arrived at the Agua Fria River crossing, just north of Rock Springs, they found the river running bank to bank, and the stage station was on the other side. It was pitch dark, and across the boiling, turbulent river, they could see the lights from the station. Buckey fetched a bucket full of rocks to throw at the mule, and Behan drove the stage. The two nuns and the two male passengers climbed to the upstream side of the stage, leaning outward to balance it against the rushing water.

The stage plunged into the river, with Buckey pelting the mules' rumps with pebbles. The mules got to deep water and began to swim, but the current swung the stage around and was carrying it downstream. Fortunately, it caught on a rock, and the mules were able to plant their feet on the bottom and claw their way up the far bank. This was but one of many such harrowing experiences on the Black Canyon Stage Line.

Stagecoaches and freight wagons continued to travel the Black Canyon Road right up to and beyond the advent of the horseless carriage in the early 1900s. Stagecoaches carried passengers up until 1917, when they were replaced by automobiles. It took three hours to get from Phoenix to the New River store. It took another seventeen arduous hours to finally reach Prescott. Although the road was improved over the years, it still took over four hours to travel from Cordes to Phoenix in the late 1920s.

THERE'LL BE A HOT TIME
IN THE OLD TOWN TONIGHT

Fires were always a menacing threat to frontier towns. The boomtowns of Prescott, Bisbee, Jerome and Tombstone all burned to the ground several times during their heydays. With all those coal oil lamps and candles, it took only one careless mistake and it was katy-bar-the-door.

The first generation of buildings and houses in those western towns were usually made of wood, and by the time the business district had burned down two or three times, the folks learned their lesson and began to rebuild with bricks and mortar.

Mining towns like Bisbee and Jerome built on hillsides were the most vulnerable. When a fire started in the lower part of town, it might be the kiss of death for the homes and buildings higher up on the slope.

Old-timers claimed you could spit tobacco juice off your front porch, and it would splatter on your neighbor's roof. When mothers let their children play outside, they had to be tethered to the house by a rope lest they fall off the yard.

The town lived through several major fires, the worst being in 1885 and 1887. It was still dry as a tinderbox in 1907 when a gas stove exploded in a local boardinghouse in Brewery Gulch, destroying seventy-six homes and damaging others. The volunteer firemen brought it under control by dynamiting other structures to create a fire break. The following year, the city established a fire department.

Several months later, on October 14, a fire broke out in a closet at the Grand Hotel, and flames quickly engulfed the whole building. Even though

many of the buildings were brick, the fire quickly spread through the business district. A newspaper reported the flames could be seen almost two hundred miles away from Pinal Peak above the town.

The firefighters were thwarted by low water pressure, as flames continued to consume the town. They finally managed to contain the fire by dynamiting some buildings, but not before it had done $750,000 in damage to homes and businesses, leaving five hundred people homeless.

Jerome, perched on the side of Cleopatra Hill, had five major fires during the 1890s. Three of those occurred between 1897 and 1899. They burned with such regularity that some religious zealots proclaimed after each big fire the Almighty was punishing Arizona's Sodom and Gomorrah for its sinful ways. A Mrs. Thomas of Phoenix, who represented the Salvation Army and claimed the gift of prophecy, declared after each fire: "God held the torch that started each of the fire and He isn't done with Jerome yet. Until Jerome repents and washed away its sins, Divine anger will not be dissipated and more fires would sear the slopes of Cleopatra Hill."

During one fire, a madam named Jennie Bauters rushed down to the fire station and promised lifetime free passes if they could rush up the hill and save her house. It's said the firefighters rose to superhuman effort as they charged up to save Jennie's place.

During its heyday in the early 1880s, Tombstone had three major fires. The first one occurred on June 22, 1881, after a local bartender decided to check the contents of a whiskey barrel. He made the mistake of peeping into the bung hole with a lighted cigar in his mouth. The barrel exploded, destroying the town's business district and did $250,000 in damage. The second happened on May 25, 1882. Within a month, the businesses were up and running again.

There was a third fire in the summer of 1882, but it didn't wipe out the town. The new Huachuca Water Works had a storage capacity of 1.1 million gallons. Pressure could shoot water 150 feet.

It was a warm, sultry evening in Prescott on July 14, 1900. The saloons and gambling casinos along Whiskey Row were gearing up for a big Saturday night shindig. Gamblers were dealing cards; the bargirls were hustling drinks. The sounds of piano music emanated from each raucous saloon. Boisterous, devil-may-care cowboys, railroaders and miners were bellying up to the bar for a night of revelry.

Yavapai's County's colorful sheriff, George Ruffner, was heard to comment, "To jail all the drunks tonight, you'd have to put a roof over the whole town."

Whiskey Row, taken from the roof of the county courthouse in Prescott, after the big fire in 1900. *Courtesy of Arizona Historical Foundation.*

Over at the Scopel Hotel on the corner of Goodwin and Montezuma Streets, a miner came in from his shift, jammed his pick candle into the wall and starting sprucing up for a night on the town. Anxious to get down to the saloons, he forgot to blow out the candle. Sometime around 10:30 p.m., the candle set fire to the wooden structure, and soon the entire hotel was engulfed in flames.

The fire quickly spread through the business district. Volunteer firemen pulling hose carts rushed out to fight the flames, which had by now engulfed notorious Whiskey Row.

Folks grabbed what they could and rescued it from the raging flames. A barber hoisted his chair and tools from the burning destruction and moved his business to the plaza's bandstand.

Down at the famous Palace Bar, loyal customers gallantly picked up the back bar and all its precious contents and carried them across Montezuma Street, where the County Court House sits today. Others picked up the piano and carried it to the safe environs of the plaza.

Prescottonians weren't going to let something like a fire spoil their Saturday evening. So while Prescott burned through the night, business resumed outdoors; the barber continued to cut hair, the bartender continued to pour drinks and the piano player kept playing.

The most requested tune that evening was "There'll Be a Hot Time in the Old Town Tonight."

WHEN OUTLAWS WERE WORTH MORE DEAD THAN ALIVE

S tagecoach robbers became such a menace on the Black Canyon Road from Prescott to Phoenix that in 1879, acting governor John J. Gosper issued a proclamation stating that the Territory of Arizona would pay $500 to anyone "who shall kill, by means of firearms, or otherwise, the highway robber while in the attempt or robbing the mail or express, or search of the passengers." The proclamation went on to offer only $300 for the capture and conviction of the same.

Murder and robbery were frequent occurrences on that mountainous stretch of road. In February 1903, Charles Goddard, station keeper at Black Canyon, was having dinner with his wife, his brother Frank, Milton Turnbull and Frank Cox when two men walked in and demanded food. Then, without warning, one pulled a pistol and fired three shots, fatally wounding the station keeper. Cox also was mortally wounded.

The two bandits were found a few weeks later living in Sonora, but the Mexican authorities were reluctant to turn the pair over to American law. A clever scheme was deployed in order to bring the killers to justice. The two were employed by the El Paso and Southwestern Railroad, and on the next payday, their checks were drawn on a bank across the border in Douglas. They were told to go there to collect their pay, so the pair hightailed it across the border to the American side to cash their checks, where lawmen were waiting. The two were brought back to Prescott, found guilty of murder on March 25 and hanged six days later. Justice was swift and sure on the Arizona frontier.

On August 26, 1882, the down, or southbound, stagecoach left Prescott at two o'clock in the afternoon. On board were Captain C.G. Gordon, a Dr. Lord and a well-known merchant named Isador Solomon. The latter had a couple of checks for $1,000 and $960. All three men were carrying cash. On a steep grade about two miles from Gillett, two masked men, one with a sawed-off shotgun, the other a six-gun, suddenly appeared and ordered the driver to halt. Next, they called upon the messenger to toss down the Wells Fargo treasure box. The passengers were then ordered to empty their pockets. Solomon had an expensive gold watch along with $63 in cash. Lord and Gordon also lost their watches, along with $50 and $365 cash, respectively. Solomon, always a gentleman, took the occasion to compliment the robbers on their good manners and the success of making such a good haul.

About that time another stage, the up from Phoenix, approached. It too was halted and the passengers ordered out. Among them were prominent Prescottonian Dr. John Ainsworth and Dave Naegle, a deputy U.S. marshal and former Tombstone town marshal. All were robbed of their watches and cash. The Wells Fargo box also had a large amount of cash.

Again, Solomon complimented the bandits on their good manners and successful haul without doing bodily harm. They seemed to appreciate his comments. Then Soloman asked if he could have his watch back. The bandits, no doubt feeling generous because of their successful heist, complied. Then Captain Gordon asked for his watch. Dave Naegle followed suit and asked for his, as it had presented to him by the grateful citizens of Tombstone.

By this time, the outlaws were running low on generosity.

"Take your confounded watch," one grumbled.

The up stage was then ordered to move out. Solomon again thanked the bandits and asked if they would return enough cash for meals and a drink at the next stop.

One of the outlaws produced a handful of silver. Solomon smiled and said, "Boys, you seem like regular fellers."

The driver was ordered to move on. The "regular fellers" were never apprehended.

North of the Black Canyon station was the station at Bumble Bee. This area also was heavily infested with bandits. Sometimes, quick action on the part of the driver foiled a robbery. One time, a stage was rolling down the hill south of Bumble Bee when a bandit stepped out and hollered, "Halt, Halt." The driver didn't heed the command, and a rifle ball from a Winchester

buzzed by his head. He kept going. The stage jostled over the curves and steep grades, the passengers expecting to be dashed on the rocks below, but they reached the bottom of the hill safely and rode into Bumble Bee. Nothing more was seen of the would-be robber.

Proving that if at first you don't succeed, try again, highwayman Dick Fellows is thought to have pulled the biggest heist. His first attempt to rob a $42,000 payroll was foiled by Wells Fargo detectives, but the persistent outlaw tried again the next day and made off with $17,000.

POSTSCRIPT

Isador Solomon arrived in Arizona in 1876 with his wife and brother. A few years earlier, Bill Munson built an adobe house near the Gila River and opened a store. The community was known as Munsonville. Solomon bought the store, and Arizona pioneer Bill Kirkland suggested the town be renamed Solomonville. In 1883, it became the Graham County Seat, and Solomon went on to become one of the founders of Valley National Bank, today's Bank One.

HOW ARIZONA LOST ITS SEAPORT

Following the Treaty of Guadalupe Hidalgo ending the Mexican War in 1848, the boundary line between the United States and Mexico was the Gila River.

One of the reasons the United States wanted to acquire Arizona and New Mexico was to build an all-weather southern wagon road and a transcontinental railroad to California. However, the best place to build a road and lay tracks was south of the Gila along the thirty-second parallel, so a railroad man from South Carolina named James Gadsden was sent to Mexico to negotiate a land purchase that today bears his name. The area included only three non-Indian communities: Mesilla, Tucson and Tubac. At the time, it looked like the boundary line would run straight to the Sea of Cortez and the future Arizona would have a seaport, but things didn't work out that way.

Gadsden was the son of Revolutionary War general Christopher Gadsden and the man for whom the Gadsden "Don't Tread on Me" Flag is named.

Surveyors like straight lines, and most boundary lines in the West are straight. For example, the northern boundary beelines from Oklahoma, New Mexico and Arizona to the eastern boundary of Nevada. So what about that diagonal line that prevented Arizona from having a seaport?

There's an enduring legend that surveyors with the Army Corps of Topographical Engineers got drunk at a cantina in the village of Nogales, and the next morning they asked the bartender for directions to the next saloon. He told them to go in a northwest direction to Yuma on the Colorado

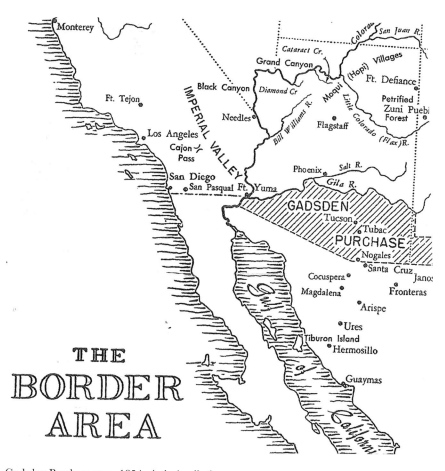

Gadsden Purchase map, 1854. *Author's collection.*

River. So, instead of following the straight line to the Sea of Cortez, they marked a diagonal line to Yuma, thus depriving Arizona of a seaport.

It's a good yarn, but it ain't true. First, there was no village of Nogales at the time, and second, the Republic of Mexico had no intention of giving up its land route to Baja California. So the diagonal line was part of the deal.

There was another reason. The Southern states wanted to acquire more territory, but the Northern states, fearing it would expand slavery, wanted to acquire just enough territory to build a wagon road and a railroad. Northern congressmen conspired with Juan Alamonte, the Mexican minister in Washington, to limit the size of the purchase. Alamonte's skilled lobbying in Congress won the day.

Congress ratified the treaty on June 8, 1854. For $10 million, the United States added 29,670 square miles to the nation. The cost figures out to about $0.39 an acre. It was the last land acquisition of the contiguous United States and it was thought by many to be a useless piece of real estate. Even the legendary Kit Carson, who knew it well, declared it so worthless "it wouldn't feed a wolf." But those mountains bore a treasure-trove of gold, silver and copper that inspired one of the greatest mass migrations of greenhorns since the children of Israel set out in search of Canaan. Boomtowns sprang up overnight boasting everything except a church and a jail.

That $10 million turned out to be quite a bargain. But alas, Arizona came close but no cigar to acquiring that coveted seaport.

TRAVELING BY STAGECOACH WAS NO PLACE FOR SISSIES

R afael Pumpelly, who rode and wrote about traveling the Butterfield Overland cross country in 1860 described a typical journey:

> *Having secured a seat in the overland coach as far as Tucson, I looked forward to sixteen days and nights of continuous travel. The coach was fitted with three seats, and these were occupied by nine passengers. As the occupants of the front and middle seats faced each other, it was necessary for these six people to interlock their knees; and there being room inside for only ten of the twelve legs, each side of the coach was graced by a foot, now dangling near the wheel, now trying in vain to find a place of support.*
>
> *My immediate neighbors were a tall Missourian, with his wife and two young daughters. The girls [were] overcome by seasickness, and in this having no regard for the clothes of their neighbors.*

Leaving the station, the driver gathered up the "ribbons" and shouted "turn 'em loose." Passengers bumped their heads on the roof as the coached bounced along the dusty road. It was sheer novelty at first, but as night fell, the hardships of coach travel was brought to all. Some managed to doze but never for long amid the rumble of the coach. Sheer exhaustion allowed some to sleep after a couple of nights on the road, but others were driven insane by the ordeal. It was reported that during one trip across southern Arizona, a passenger suddenly leaped from a moving stage and ran off screaming into the desert, never to be seen again.

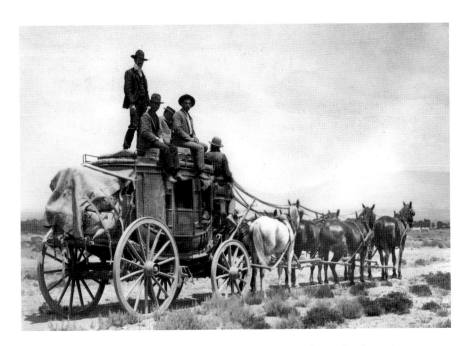

Before the arrival of the railroads in the 1880s, the most popular mode of travel was stagecoach. It was well into the twentieth century before the horseless carriage replaced stagecoaches in Arizona's rugged interior. *Public domain.*

One passenger recalled how a runaway team pulled his coach down a steep bank, bouncing the body completely off the running gear. The mules bolted, dragging what was left behind them. After a short distance, the wheels flew off, and when the mules were caught, they were dragging just the axles. One passenger was badly cut and the others stunned, but in one hour, after patching the stagecoach together, they hit the trail again.

Another wrote:

> *Twenty four mortal days and nights—must be spent in that ambulance; passengers becoming crazy with whiskey, mixed with want of sleep, are often obliged to be strapped into their seats; meals dispatched during the ten minute halts are simply abominable, the heat excessive, the climate malarias; lamps may not be used at night for fear of non-existent Indian raids.*

A surefire way to handle customer's gripes was developed by one driver: "We had a way of managing them…[W]hen they got very obstreperous, all we had to do was yell 'Indians' and that quieted them quicker than forty-rod whiskey does to a man."

The driver had unlimited authority on the expedition. Women were special and were treated with great respect. The standard punishment for those who took liberties with a female was to be set afoot, whether in dangerous Indian country or not. It was considered unwise to discuss politics or religion on board.

Passengers were appalled by the dirt and squalor that greeted them at the station. Built of adobe with floors "much like the ground outside" one wrote, "except not so clean" and interiors black with flies, there was little to attract the discriminating passenger. Many stagecoach relay stations had community toothbrushes hanging on strings for the passengers.

Meals were worse: tough beef or pork fried in a grime-blackened skillet, coarse bread, mesquite beans, a mysterious concoction known as "slumgullion," lethally black coffee and a "nasty compound of dried apples" that masqueraded under the name of apple pie.

This went on day after day. The story was told of the stationmaster who set a plate of fat pork before a traveler who said, "Thank you, but I can't eat it."

"Very well," came the reply, "jest help yourself to the mustard."

23

YONDER COMES THE TRAIN

The chance to get rich quick as a uniquely American article of faith was virtually born in the West. Almost since its beginning, America was the only country in the world where folks were encouraged, through their own labors, to rise above their fathers' stations.

The rocky wilderness of the American West turned out to be a veritable treasure-trove of gold, silver and copper. For the first time in the history of mankind, the riches uncovered were finder's keepers.

Previously, the finder had to share the wealth with a monarch, which was usually a royal *veinte porciento* (20 percent) if it was ruled to be ore. However, if the king ruled it was a treasure, the tax collector could help himself to a whopping 95 percent. Not so in the United States. With a single lucky break, one could instantly make as much money as they could spend in a lifetime. And it was those railcars pulled by sturdy little iron-bellied locomotives that made it all possible.

But when the company men started to build lines into the mountains, they were warned they would be stopped cold by perpendicular grades, rugged canyons and gorges that were so steep a mountain goat had to shut his eyes and walk sideways.

The rail lines had more switchbacks, lazy loops and kinks than a cheap lariat. It sometimes took 260 miles of track to go just 60 miles. Passengers claimed you could look outside the window of a car and see the front of the train going in the opposite direction.

All this was made possible by the invention of the steam engine in England in 1825. A year later, James Watt's creation arrived in the United States, and by the 1850s, trains were traveling at speeds of twenty-five miles per hour. Since the time of the Romans, people had only been able to travel at speeds of four miles per hour.

Those little locomotives moved at a snail's pace; people laughed and called them "coffee pots" and "peanut roasters." It was said a reasonably sober fat lady could outrun one of them in a downhill race. It took a lot of water and coal to run them. They used one thousand gallons of water to go fifteen miles and burned from six to nine tons of coal an hour.

But they did the job. They brought men and equipment into the mountains and took the gold and silver out by the ton. America became one of the richest nations in the world.

By the spring of 1877, the Southern Pacific Railroad was building east from California along the thirty-second parallel on the first transcontinental line through Arizona. After getting permission from the federal government, the railroad spent the summer building a bridge across the Colorado River. Ironically, when workers started to lay the track across the bridge, another branch of the government wouldn't allow them to cross a federal stream. At the time, there were only five soldiers manning Fort Yuma: the commanding officer, Major Thomas Dunn, a doctor, a sergeant, an enlisted man and a prisoner. With the exception of the prisoner, it was their duty to stop the railroad come hell or high water.

Fearing the track layers might try surreptitiously to lay the tracks at night, Major Dunn posted a guard on the bridge each evening until eleven o'clock. On the evening of September 29, 1877, the construction crew waited until the guard went off duty then they quietly began laying down track. Just before dawn, a rail was accidentally dropped with a resounding noise, and all four troopers rushed to the bridge with fixed bayonets. They stood bravely on the tracks but quickly realized they were no match for the approaching steam engine chuffing toward them. Deciding discretion was the better part of valor, they jumped out of the way and let it pass. That morning, the Southern Pacific Railroad rolled triumphantly into Yuma.

The building of the transcontinental railroads was a major milestone in Arizona history. Up to then, the main means of transportation to bring people and supplies into the central part of the vast territory was by stagecoach or wagon. Naturally, there was cause for great celebration in Tucson on March 20, 1880, when the Southern Pacific rolled into town marking the end of those hot, dusty stagecoach trips across barren deserts.

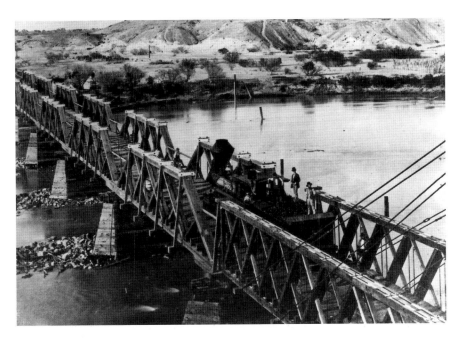

Southern Pacific Railroad crossing the Colorado River. *Courtesy of the Arizona Historical Foundation.*

Travel time for passengers going to Los Angeles was reduced from five days to less than one with the cost dropping by two-thirds. Freight shipments that previously took three months now arrived in four days.

The Town of Tombstone presented Tucson with a silver spike in honor of the occasion. After a day of spirited celebrating, speech-making and ballyhooing, self-congratulatory telegrams were sent to dignitaries from New York to San Francisco. The Old Pueblo had arrived, and it wanted everybody to know about it. A few of those who'd overindulged in strong spirits, including Mayor Bob Leatherwood, took it upon themselves to conjure up a telegram to send to Pope Leo XIII at the Vatican, which read as follows:

> *To His Holiness the Pope of Rome in Italy: The mayor of Tucson begs the honor of reminding Your Holiness that the ancient and honorable pueblo founded by Spaniards under the sanction of the Church more than three centuries ago, and to inform Your Holiness that a railroad from San Francisco, California now connects us to the entire Christian World.*
> *Signed R..N. Leatherwood, Mayor*

Before the telegrapher could send the message, some of the more discreet citizens advised him to reconsider. Not wanting to cast a pall over the celebration by having the pope ignore Tucson's coming-out party, it was said they slipped him a few bucks to can the message and allow them to write a reply for the celebrants.

That being done, the telegrapher carried the message over to the assemblage, where Mayor Leatherwood was holding court. Without bothering to preview the pope's reply, the mayor called the crowd to attention and read aloud:

> *His Holiness the Pope acknowledges with appreciation the receipt of your telegram informing him that the ancient city of Tucson at last has been connected by rail with the outside world and sends his benediction, but for his own satisfaction would ask, where the hell is Tucson?*

On September 22, 1880, the tracklayers on the Southern Pacific crossed the Arizona–New Mexico border. Meanwhile, the Santa Fe was laying track across the northern part of the territory along the thirty-fifth parallel. In August 1883, the Santa Fe Railway, née the Atlantic and Pacific, would complete a second transcontinental line across Arizona along the thirty-fifth parallel. The two Arizona lines would be the only all-weather routes of America's five transcontinental cross-country lines.

Their next tasks would be to construct branch lines into the rugged interior of the territory. A branch line from Maricopa on the Southern Pacific would reach Phoenix in 1887, but the capital city wouldn't be on the Southern Pacific main line until 1929, when tracks were laid along the Gila River to the Salt River Valley. Another line—nicknamed the "Peavine" because of its many switchbacks and lazy loops—connecting the Santa Fe to the territorial capital would be completed in 1895, marking a date that historians like to call the closing of the frontier in Arizona.

SUGGESTED READING

Ahnert, Gerald. *The Butterfield Trail and Overland Mail Company in Arizona, 1858–1861*. Canastota, NY: Canastota Publishing, 2011.

Bates, Albert R. *Jack Swilling: Arizona's Most Lied About Pioneer*. Tucson, AZ: Wheatmark, 2007.

Blair, Robert. *Tales of the Superstitions: The Origins of the Lost Dutchman's Legend*. Tempe: Arizona Historical Foundation, 1975.

Boessenecker, John. *When the Law Was in the Holster: The Frontier Life of Bob Paul*. Norman: University of Oklahoma Press, 2012.

Browne, J. Ross. *Adventures in Apache Country*. New York: Harper Press, 1871.

Cleland Robert G. *This Reckless Breed of Men*. New York: Knopf, 1950.

Faulk, Odie. *Tombstone: Myth and Reality*. New York: Oxford University Press, 1972.

———. *The U.S. Camel Corps*. New York: Oxford University Press, 1973.

Gilbert, Bil. *Westering Man: The Life of Joseph Walker*. New York: Atheneum, 1983.

Gressinger, A.W., and Harold A. Wolfinbarger Jr. *Charles D. Poston*. Globe, AZ: Dale Stuart King, 1961.

Hanchett, Leland Jr. *Catch the Stage to Phoenix*. Phoenix, AZ: Pine Rim Publishing, 1998.

Hutton, Paul Andrew. *American Experience*. Season 20, episode 4, "Kit Carson." Aired February 18, 2008, on PBS.

———. *The Apache Wars*. New York: Crown Publishing, 2016.

———. "Kit Carson and the Mountain Men." *True West Magazine* (December 2017): 22–27.

Kollenborn, Tom. "The Origin of the Lost Dutchman Mine Story." Apache Junction Public Library, Tom Kollenborn Chronicles, https://www.ajpl. org/wp/wp-content/uploads/2017/02/8-8.00.pdf.

Ligenfelter, Richard. *Steamboats on the Colorado*. Tucson: University of Arizona Press, 1978.

Monahan, Sherry. *Taste of Tombstone: A Hearty Helping of History*. Albuquerque: University of New Mexico Press, 2008.

———. *Tombstone Treasures: Silver Mines and Golden Saloons*. Albuquerque: University of New Mexico Press, 2007.

Myrick, David F. *Railroads of Arizona*. Vol 1. Berkeley, CA: Howell North Books. 1975.

O'Neal, Bill. *The Arizona Rangers*. Austin, TX: Eakin Press, 1987.

Parkhill, Forbes. *The Blazed Trail of Antoine Leroux*. Los Angeles: Westernlore Press, 1965.

Parsons, George. *The Private Journal of George Whitwell Parsons*. Tombstone, AZ: Tombstone Epitaph, 1972.

Quebbman, Frances. *Medicine in Territorial Arizona*. Phoenix: Arizona Historical Foundation, 1966.

Ricketts, Norma Baldwin, ed. *Arizona's Honeymoon Trail and Mormon Wagon Roads*. Mesa, AZ: Maricopa East Company Daughters of Utah Pioneers Mesa, 2001.

Rosebrook, Jeb J. "The Old Black Canyon Highway." *Arizona Highways Magazine* (August 1994).

Schmitt, Jo Ann. *Fighting Editors*. San Antonio, TX: Naylor Company, 1958.

Sonnichsen, C.L. *Billy King's Tombstone: The Private Life of an Arizona Boom Town*. Caldwell, ID: Caxton Press, 1942.

Sweeney, Edwin. *From Cochise to Geronimo*. Norman: University of Oklahoma Press, 2010.

Trimble, Marshall. *Arizona: A Cavalcade of History*. Tucson, AZ: Rio Nuevo Publishers, 2003.

———. *Arizona Adventures*. Phoenix, AZ: Golden West Publishers, 2006.

———. *A Roadside History of Arizona*. Missoula, MT: Mountain Press Publishing, 2004.

———. *Ash Fork: A History of the Santa Fe Railroad and Route 66*. Charleston, SC: Arcadia Publishing, 2008.

———. *In Old Arizona*. Phoenix, AZ: Golden West Publishers, 2006.

Wilson, R. Michael. *Tragic Jack: The True Story of Arizona Pioneer John William Swilling*. Billings, MT: Two Dot Publishing, 2007.

ABOUT THE AUTHOR

Marshall Trimble has been called the "Will Rogers of Arizona." He frequently appears as a goodwill ambassador for his native state. He can deliver anything from a serious history lecture to a cowboy folk music concert with his guitar.

Considered the dean of Arizona historians, he taught Arizona history at Scottsdale Community College for forty years before retiring in 2014.

He answers questions about the Old West from readers all over the world in *True West Magazine*'s popular column Ask the Marshall. He's also appeared on many national television documentaries on Arizona and the Old West

His first book was published in 1977 by Doubleday & Company, New York. Since then, he's written more than twenty books on Arizona and the West.

He's been inducted into several halls of fame, including the Arizona Veterans Hall of Fame and the Arizona Music and Entertainment Hall of Fame.

Trimble has received many honors as a historian, writer and performer. In 1997, the governor of Arizona appointed him the official state historian. In 2000, he was selected as one of Arizona's representatives in the Library of Congress's Local Legacies. In 2003, he was named a charter member of the Arizona Culturekeepers.

In 2004, the Daughters of the American Revolution awarded him their Medal of Honor for leadership and patriotism.

A former U.S. Marine, in 2004, he received the Semper Fi Award from the U.S. Marine Corps Scholarship Foundation.

In 2006, he received a regional Emmy for hosting the television show *Arizona Backroads*.

In 2007, the Arizona Office of Tourism honored him with a Lifetime Achievement Award for his many years of service to his native state.

He is a charter board member of the National Wild West History Association, and in 2010, he received the WWHA's Lifetime Achievement Award.

That same year, the Arizona Historical Society presented him its distinguished Al Merito Award in recognition of his lifetime service in promoting Arizona history.

Trimble served on the Arizona Centennial Commission. He also was a member of the Governor's Commission in 1987 celebrating the state's seventy-fifth anniversary.

In 2012, he was presented the President's Silver Star Award from the Wild West History Association for his "Distinguished and unselfish service on behalf of the advancement of WWHA and the documentation of western history."

In 2012, he received the Anam Cara Award Soul Friend for outstanding service to the community, from the Irish Cultural Center, Phoenix.

In 2012, he was selected for the U.S. State Department's Cowboy Hall of Fame Tour, a goodwill tour with a group of World Champion rodeo cowboys and cowgirls to the nation of Kyrgyzstan to share American cowboy culture with the people of that country.

He was inducted as a 2014 Historymaker by the Historical League of the Arizona Historical Society.

True West Magazine honored him as the Westerner of the Year for 2015.

In 2016, he was appointed to the board of directors for the Arizona Historical Society and served one term as president, 2015–16.

Trimble has served more than thirty years as a founding member of the Arizona Peace Officer Memorial Board, honoring officers who died in the line of duty.

Marshall was born in Mesa, Arizona, and grew up in Ash Fork, a small railroad town along old Route 66. He makes his home in Scottsdale with his wife, Vanessa.